GRAVE MATTERS

MARK C. TAYLOR AND DIETRICH CHRISTIAN LAMMERTS

REAKTION BOOKS

Published by Reaktion Books Ltd
79 Farringdon Road, London EC1M 3JU, UK

www.reaktionbooks.co.uk

First published 2002

Printed in Hong Kong

British Library Cataloguing in Publication Data

Taylor, Mark C., 1945–
 Grave Matters
 1. Sepulchral monuments 2. Burial
 I. Title II. Christian-Lammerts, Dietrich
 393. 1

ISBN 1 86189 117 2

GHOST STORIES

'… the thought of death is a good dancing partner.'
SØREN KIERKEGAARD

Beginning Ending

Origins are always obscure even when beginnings are not. I know when this work began but am not sure when or how it originated. *Grave Matters* began on a lazy day in the summer of 1956, when I was eleven years old. It was one of those days when the New Jersey heat and humidity made it too hot for my brother, Beryl, and me to play outside. We had finished lunch, and I was sitting on the couch in the living room. Bored but not tired, I picked up the family Bible, which had been on the step table with my mother's mementoes and knickknacks for as long as I could remember, and distractedly turned its pages. Maps, photographs, drawings and paintings rather than words attracted my attention: 'The Cedars of Lebanon', 'The River Jordan', 'Christ with the Fourth Commandment', 'Sermon on the Mount', 'Jesus Healing the Man with Dropsy', 'The Via Dolorosa', 'The Crucifixion', 'After the Resurrection – Jesus by the Lake', 'The Ascension'. Pictures made it all seem so real. But while lost in a world that claimed to be more than imaginary, I stumbled on something completely unexpected. Between the Old and the New Testaments, I discovered a 'Family Register' with four

pages: 'Parents' Names', 'Children's Names', 'Marriages' and 'Deaths'. On the first page, the names of my mother and father were written in my mother's hand. On the second page, I was startled to read the names of not two but *four* children: before my name, my mother had written 'Baby Girl Taylor', and between my name and my brother's name, 'Brent Taylor'. The marriage page was blank; on the page labelled 'Deaths', she had written:

> Baby Girl Taylor Nov. 9, 1944
> Brent Taylor May 25, 1954

As I struggled to absorb what I had read, my head started spinning. For a few minutes, I sat quietly trying to regain my balance. Eventually, I went into the kitchen where my mother and father were finishing lunch, put the Bible open to the page with the names of four children on the table and said: 'What does *this* mean?' They glanced at the book and then stared at each other for what seemed like an eternity. I shall never forget the look in their eyes. They had known that this day would come but obviously were not yet prepared for it. Though they were both teachers – my father taught biology and physics, my mother American literature – they never found a lesson they could pass on to others in the death of their children. Attempting to avoid the question, my mother began to make up some kind of story. But my father quickly interrupted her: 'No, it's time for him to know.' He paused, took a deep breath and turned his piercing brown eyes towards me. In a voice measured by the weight of his words, he said: 'You had a sister and another brother. Your sister died at birth a year before you were born, and your brother, who was born almost two years after you, was very sick and was never able to come home.'

I do not remember what else was said that afternoon or in the days that followed. But that moment remains seared in my memory in ways I still cannot fathom. Somewhere in its depths, I suspect, lie the origins of *Grave Matters*.

For the next six years, nothing more was said about my dead brother or sister – absolutely *nothing*. In the summer of 1963, our family drove from our home in New Jersey to California and back. Though billed as a vacation, it was more of an extended lesson in history, geography and ecology. Teachers, it seems, can never stop teaching. On our way out, we stopped in Kankakee, Illinois, to see the town where our parents had lived and worked during the War and where I was supposed to have been born. After driving around the factory where my father had been a chemical engineer in a facility that produced explosives for the campaign in the Pacific, we stopped on the street where they had lived in a third-floor flat. We could not enter the house, but my mother described their small living room, bedroom and kitchen in vivid detail. Even at

the time, I realized that she was speaking more to herself than to us.

I didn't know how desperately lonely she had been in Illinois until many years later, when, while looking for stamps in her desk, I discovered a diary she had kept during the year before my sister's birth/death. It was a small daybook with a light blue cover and pages bordered with light green designs. For each day, there was a biblical quotation. The vivid words and carefully wrought phrases were those of the literature teacher she had been and once again would become. Until I read these pages, I had not realized that when she described the flat while sitting in a car parked on a Kankakee street, she had failed to mention a second bedroom – the room she had prepared for their first child. The scene she depicted in the diary was bright with expectation: the crib, the curtains, the freshly painted walls, the quilt she had so lovingly crafted. In her private daybook, I learned that my sister's name was to have been Noel – my father's name. I do not recall any diary entries after the death. I had not finished reading the diary when I heard my mother's footsteps coming up the stairs and quickly returned the book to its hiding place. She never knew I had read it.

As we were about to leave Kankakee, my father said: 'There is one more place we are going to stop. We want to go to the cemetery where your sister is buried. We have not been back since we left Illinois; it's important for both of you to come with us.'

The cemetery, which was on the edge of town, was unremarkable. After parking the car, my father reached for his wallet and pulled out a small, tattered card. Looking over his shoulder, I saw that it was a form from the cemetery with the grave location typed on it. I had never known that he always carried this card with him. The only maker on the grave was a small, flat stone with no inscription. As the four of us stood around the grave, nothing was said. We silently returned to the car and continued to drive West.

A final detail from that summer's trip sticks in my memory. We spent the last night on the road with my father's brother near Gettysburg, Pennsylvania. Though our two cousins were older, my brother and I had fond memories of hunting with them on the nearby farm where my father and his family had grown up. We were eager to share stories from our trip with our cousins and were disappointed to discover that they were out for the evening. Tired from the long drive, we went to bed early. Around 4 a.m., a State Trooper pounding on the door woke us up. I heard him say to my uncle: 'I'm afraid I have some bad news. There has been an accident. Your daughter-in-law is dead, and your son, Noel, is in critical condition. I think you should come to the hospital with me immediately.' As we sat in silence waiting for further news, my mother was the first to speak. 'I had the strangest experience during the night. I was awakened by the sound of church bells. I looked at the clock and it was 2:10.'

Several hours later, my uncle returned. 'Sharon's dead and I don't think Noel is

going to make it. An eighteen-wheeler ran the stoplight at Cross Keys and hit them broadside. Sharon was crushed and Noel was thrown from the car. He's unconscious and bleeding internally. They aren't sure where the blood's coming from. The police say the accident occurred at 2:10.' With cries of anguish surrounding me, I turned towards my mother. Our eyes met in a gaze filled with understanding and incomprehension. I never spoke about that moment with her or anyone else and still do not know what to say about it. I have never believed in accounts of such experiences; yet we all undoubtedly heard what she had said.

In the last years of their lives, my parents occasionally mentioned either their daughter or their son Brent, but it was clear that they did not want to discuss what had happened. It took several years of prodding before my father explained reluctantly. My sister had died of strangulation when the umbilical cord became wrapped around her neck at birth, and my brother had had Down's Syndrome. He lived for seven years but weighed only eleven pounds when he died. My mother never saw either child. How they dealt with such unspeakable losses – and there were others – is a secret they took to their graves. Nor did my brother and I ever talk about our dead sister and brother or about our visit to the grave in Kankakee. Perhaps that is because Beryl had come as close as possible to death when he was merely three-and-a-half weeks old. Only the riskiest surgery unexpectedly saved his life.

Though we did not speak, there were several moments over the years, I believe, when we both knew we were not talking about it. This troubled silence was not broken until both our parents had died. After my father's funeral, my brother and I stayed together in the house where we had grown up to clean it out and prepare it for sale. It was a remarkable week of labour and memory. 711 was the only house my parents had ever owned, and, though they insisted otherwise, they had a *very* hard time throwing anything away. Their lives as well as our own were woven into and out of the things we had to sort. Not only the things but also the photographs – boxes and boxes of photographs and tray after tray of slides. Dad had been a serious photographer, and, as a child, I had spent countless hours with him in the darkroom. Scattered through his work, I found hundreds of photos I had taken and proudly developed and printed. In the memory boxes and books of others – especially those to whom we are closest – we discover how fragile are the ties that bind lives together. What should we save from a lifetime of collecting? How do we decide what stays and what goes? Was there any way to silence haunting echoes: 'When we're dead and gone, don't you guys throw this out. It's valuable; some day you or your kids will want it.' We knew, of course, that what they feared was not the loss of their things but the loss of our memories about their lives. What we never found was what I most desired: my mother's secret diary.

We eventually completed the task that had forced us to relive our lives as though watching one of Dad's home movies. Sitting in the attic in the midst of carefully sorted piles of stuff, I turned to my brother and said: 'You know, there's one more thing we have to do before we leave.' He looked at me with a gaze I remember having seen only once before and without hesitating said:

> 'Yeah, I know.'
> 'What?'
> 'We have to visit Brent's grave.'
> 'That's right. But how did you know?'
> 'I don't know; I just knew that's what you were going to say.'
> 'Have you ever been there?'
> 'Yeah, when I was in high school, I went to the cemetery and found it.'
> 'I've never been there. I thought about it several times but never went. I don't know why.'
> 'Probably never will.'

I have never been able to understand that conversation – any more than I have been able to comprehend my mother's belief in bells tolling death in the depth of night. After a lifetime of not talking about it – or of talking about it by not talking about it – how did we both know at the same instant that it was time to break the silence?

That afternoon, we went to the cemetery to look for the grave. My brother has a remarkable memory and after more than twenty years went straight to the spot where he knew the grave was located. There was no marker. 'This is where it is; I'm sure of it. There was a marker here with his name on it the last time. I can picture it as clearly as if it were yesterday.' We went to the cemetery office and asked a clerk to check the records. My brother was, of course, right. When we returned, we uncovered a small stone with no inscription – just like the one marking Noel's grave in Kankakee. No-one could explain what had happened to the marker my brother remembered. So we gave ourselves one last task before leaving town after what turned out to be the final night in the house that had been the only childhood home we had known: we arranged for a proper marker for Brent's grave.

In the years between our visit to the graves of Noel and Brent, I started doing gravestone rubbings of people I half-affectionately called my ghosts. Like so much else in my life, it started with Kierkegaard. Having written about Kierkegaard for more than a decade, in 1984 I made a pilgrimage to his grave with my eleven-year-old son Aaron. In a twist 'the master of irony' always relished, *kirkegaard* (I had learned a decade earlier) means 'churchyard' or 'cemetery'. I climbed the fence surrounding the grave and told

Aaron to follow me. Every time a siren sounded – and there were many that morning – Aaron was afraid that the police were coming to arrest us. I taped thin white linen over the tombstone and quickly rubbed a large black crayon over the surface. Our clandestine operation went undetected, and we returned with our trace of Kierkegaard.

In the following years, I added other rubbings to my collection. After Kierkegaard, the site I most wanted to visit was Hegel's grave, but, when I was in Berlin in the late 1980s, I was unable to find the cemetery. A few years later, an unexpected package from a former student arrived in the post. Opening it, I found a rubbing of Hegel's gravestone. I knew then my student had truly understood the lessons I taught. When I eventually went to Hegel's grave myself, I found it covered with ivy. I pulled out a clump and smuggled it through Customs back into the United States; the ivy is still growing in my living room. Gradually, I added other rubbings to my collection – Melville, Poe, Sartre, Marx – and started framing them to hang in my living room, where they now cover an entire wall. As the collection grew, I began to imagine the graves of other writers, artists, architects and philosophers. Where were they buried? Did they have grave markers? What was inscribed on their tombstones? Did their graves tell us anything about their lives? While pondering such questions, I started to dream of doing a book of photographs of the graves of the cultural figures who created the modern world. *Grave Matters* is the realization of that dream.

One afternoon after I had decided to pursue this project, my good friend Paul Lieberman, who is a distinguished journalist for the *Los Angeles Times*, was visiting me in Williamstown. Sitting beneath my grave rubbings, which most people ignore or avoid as odd living-room 'art', I described the book I was planning. Paul, who has a keen eye for the dark side and had always been intrigued by my strange 'wall of death', began pressing questions. Gesturing towards the rubbings, he asked: 'So what's going on with all of this?'

> 'They are my ghosts.'
> 'What do you mean, *"your ghosts?"*'
> 'You know, the thinkers and writers who are important for me.'
> 'Yeah, sure, but what's *really* going on? Why these guys? And why here on your living room wall? You're not coming clean with me, where's the "real stuff" you're always talking about?'

Like any good investigative reporter, Paul is able to get you to express what you know but have never quite said. In the course of the next few hours, we wandered from modern theology, philosophy, literature and art to my dead sister and brother. As the

tale unfolded, it became clear to both of us that the multiple ghosts in my story could not be separated from each other. I had always wondered why I was so drawn to Kierkegaard from the moment I first started reading his work. Paul's probing led me to suspect that in Kierkegaard I detected traces of graves I had visited years earlier and heard the melancholy voice of 'unhappy consciousness' which drove my mother into the silence from which she never emerged even, or perhaps especially, when she spoke. And I came to realize more than ever that in Hegel's worldly philosophy, I sought a way out of the interminable mourning of unhappy consciousness. Kierkegaard and Hegel have never been merely theologians or philosophers for me; rather, they and their writings represent alternative forms of life or modes of being-in-the-world between which life is suspended.

The more I have lived and read, the more I have become convinced that our lives are, in Don DiLillo's fine term, 'webby'. Our lives are knotted together in webs of relations that know no end. As I have traced the ghosts knotted in my life, the web has become ever more complex. While the list of graves visited in this book is necessarily partial and unavoidably incomplete, I would insist that these are not merely my ghosts but spectres we all share, because they are the people who are largely responsible for shaping the world we mistakenly call 'our own'. These men and women are not merely dead and gone but continue to haunt us in ways known and unknown. As they live on in us, so we now live through them. *Grave Matters* is, among other things, a *memento mori* that provides the occasion for pondering death during an age that apparently denies it. But more is involved in the following pages: to gaze at these photographs is to look in a mirror where we see faces we thought were our own in the uncanny images of ghosts.

Inventing Death

While necropolises can be found in the ancient world, the cemetery as we know it today is a modern invention, reflecting a modern sense of self. The word harbours rarely detected religious echoes. Cemetery derives from the Latin *coemeterium*, which, in turn, can be traced to the Greek *koimeterion*. A *koimeterion* is a sleeping room or burial place. The stem of the verb *koiman* ('to put to sleep') is *kei*, which means 'lie down', 'sleep'; 'settle'; hence 'home', 'friendly', 'dear'. A cemetery, then, is something like what Philippe Ariès aptly described as a 'holy dormitory of the dead', which, far from threatening, was originally something like the home to which we all return.[1] The sleep of death could be either permanent or temporary. In the Early Christian tradition, which has been so important for shaping the space and determining the significance

of cemeteries and graves in the West, the cemetery was seen as a temporary resting place where the dead awaited resurrection. A look at cemeteries in the West is another reminder that death and the dead lie at the very heart of the Christian religion. The point is not merely that the climax of the Christian drama is the death of Jesus and, by extension, the death of God; less often noticed, though no less important, is the fact that the Early Christian community idealized death and worshipped those who died for their faith. By imitating Jesus even to the point of death, the martyrs became quite literally the centre around which the Church was built.[2] Early Christian churches, constructed over the burial site of a martyr, had altars shaped like tombs. When the number of churches exceeded the number of martyrs, the bodies of martyrs were broken up and distributed to different communities, where they were buried under altars. As God's presence sanctified Jesus, so the martyr's bodily presence sanctified the space of the church. In church architecture of the era, everything revolves around the holy centre where the martyr or the relic is buried. This sacred geography created a metonymic chain held together by a belief in sanctification by association and the correlative desire to be buried as near to the altar as possible. As Ariès points out in his magisterial study *The Hour of Our Death*, this valorization of the space of the dead as sacred represents a significant change: 'When religious writers and ecclesiastical law broke with ancient tradition and required burial of the dead near sanctuaries frequented by the living, they were affirming the benefic character of an area regarded by the ancients as malefic.'[3]

During the Middle Ages, church architecture became the blueprint for remapping the social structure of the living in the space of the dead. Social rank determined proximity to the altar. Though initially limited to the clergy, by the thirteenth century permission to be buried inside the church had been extended to the nobility, aristocrats and, eventually, wealthy commoners. As one moves from the centre to the periphery of the church, space becomes less sacred and social rank declines: martyr/saint, clergy, nobles, artisans and merchants.[4] The same principle informs the organization of the burial space surrounding the church. Financial rather than theological considerations led to the extension of burial rights. Burial in the church brought with it an endowment for the maintenance of the grave and the conduct of services, which became a significant source of income for many churches.

During the Middle Ages, the line separating life from death was not as sharply drawn as it is today. The living and the dead mingled and regularly influenced each other. Perhaps this is the reason that Ariès characterized this era as 'the tame death'. Death, which usually was public and communal, customarily was accepted with tranquillity. What was most feared was an unexpected or accidental death, which would not permit the person to prepare adequately for the next life and the family and

community to mourn their impending loss. Salvation depended less on how one lived than on how one died. The dead passed into a state of peaceful sleep while awaiting salvation, which, it is important to note, was believed to be collective.

While the clergy and socially established citizens were interred in or near the church, the poor were buried in common graves with no markers throughout the Middle Ages. When first established, these cemeteries were outside town limits. But as cities grew, they eventually encircled the graveyards. Since the conditions in these mass graves were usually horrific, the proximity of the living to the churchyard posed a serious threat to public health. By the sixteenth century, common graves had expanded to pits measuring as much as 15 by 18 by 30 feet and containing up to between twelve and fifteen hundred corpses. When these graves were full, they were covered lightly with earth, and bodies were allowed to decay.[5] Saints-Innocents, though only 400 by 200 feet, was the largest cemetery in Paris and legendary for soil in which bodies decomposed extraordinarily rapidly. In the eight hundred years following its opening in the ninth century, two million people were buried there.[6] To cope with the growing number of dead, decayed corpses were disinterred and bones put on display in charnel houses, ossuaries and galleries surrounding the churchyards or under the eaves of the churches. 'The charnels', Ariès explained,

> were exhibits. Originally, no doubt, they were no more than improvised storage areas where the exhumed bones were placed simply to get them out of the way, with no particular desire to display them. But later, after the fourteenth century, under the influence of a sensibility oriented toward the macabre, there was an interest in the spectacle for its own sake.[7]

The communality of death and salvation, and, as a correlative, the anonymity of the dead, began to disappear with the rise of individualism in the early modern era. Although Augustine created the genre of autobiography in AD 381 with his classic *Confessions*, it was not until the twelfth century that the spread of wealth and education led to the insistence that everyone had a personal biography. During the late Middle Ages, the individual person assumed new social, political and economic significance. This changing status of the self was expressed in the anxious quest for salvation underlying Martin Luther's Reformation theology. When Luther declared that salvation did not depend on *public* participation in the church *universal* but was the result of the *individual's private and personal* relationship to God, he not only broke with the Catholic Church but prepared the way for what still remains the predominant understanding of selfhood in the West. Rather than being communal, salvation

was, in Luther's theological framework, entirely an individual matter. In contrast to classic medieval philosophy, Luther insisted that human beings were not constituted by participation in eternal essences but defined themselves throughout their lives by their personal decisions. As Jean-Paul Sartre would declare over four centuries later, 'existence precedes essence.' Life is not programmed, because individuals are for eternity what they become through their existence in time. The events of every individual's life can be woven together to form a story that defines his or her personal identity. During the Reformation, the growing sense of individual responsibility led to the recognition of the decisive importance of temporal existence, as well as the decline of rituals of intercession for the dead and, as a correlative, the rejection of the Catholic doctrine of purgatory. The impossibility of influencing the eternal destiny of deceased loved ones created an unprecedented distance between the living and the dead.

With the transition from feudalism to capitalism, Luther's religious notion of subjectivity became an economic and social reality in bourgeois individualism. Protestantism, especially Calvinism, is inseparably bound to the rise of capitalism. Though the human will remains critical for establishing an individual's identity, for Protestants, salvation always comes by grace rather than works. Individuals can fall into sin but cannot earn redemption by their own deeds. With eternity hanging in the balance, theologians and clergy sought to allay anxieties by finding signs of salvation in worldly success. For ordinary believers, this theological distinction was difficult to grasp, and worldly success tended to be seen as the cause rather than the effect of salvation. Material profits gained through individual initiative foreshadowed eternal rewards to be enjoyed in life after death.

The changing notion of self entailed in new religious practices had an impact that extended far beyond theology. The social and political upheavals which created the modern world would have been impossible without the invention of the modern subject. The American and French revolutions were founded on the related principles of individual freedom and personal responsibility. The shifting notion of self eventually altered the understanding of death and transformed the architecture of cemeteries as well as the design of graves. One of the most important manifestations of these changes was the Decree of 23 Prairial, Year XII, issued in Paris in 1804.[8] This proclamation prohibited burial inside churches and, more importantly, declared that bodies could not be 'superimposed but must always be juxtaposed'. This new regulation put an end to mass burial as it had been practised throughout the Middle Ages. As Ariès pointed out, '… this represents a complete break with the past. Private graves, which until now had been reserved for those who paid for them, are henceforth the rule. Even the graves of the poor must be separated from one another.'[9] Authorities

underscored the privatization of the grave and individualization of death by granting everyone permission to purchase a grave site and erect a monument in public cemeteries. During the first half of the nineteenth century, the growing number of grants in perpetuity and hereditary rights to burial sites created space problems and led to the rapid expansion of cemeteries. As cemeteries grew, their architecture changed: the quasi-concentric structure of church and churchyard began to give way to a gridded necropolis mirroring the spreading metropolis. The democratization of burial did not abolish social hierarchy in these cities of the dead, however. In Paris, for example, Père-Lachaise was created for wealthy, socially prominent individuals who could afford to purchase burial sites in perpetuity.

The Decree of Prairial led to another practice, which had been relatively rare until the modern era: the use of tombstones and monuments to mark the burial site and/or memorialize the dead. In ancient and Early Christian cemeteries, tombs had marked the actual spot where the dead person was buried. Most tombs bore inscriptions recording the deceased's name, family position, rank or profession, date of death and relation to the person responsible for burial. From the fifth century through the early Middle Ages, however, individual graves, tombs and inscriptions vanished. Around the eleventh century, funerary inscriptions began to reappear, following a pattern we have already observed: starting with clergy and nobles, the practice spread to the wealthy and, eventually, to all people. In some cases, the epitaphs and monuments on which they were inscribed were very elaborate, in others quite modest. Unlike tombstones, monuments and memorials often were not located at the place of burial. The earliest epitaphs for ordinary people were simple and non-stylized. They established the person's identity by recording the deceased's name, profession and date of death (but, initially, not the date of birth). By the fourteenth century, prayers for the dead and, occasionally, exhortations to the living were being included on gravestones. Such individualized inscriptions, however, were uncommon until the modern era. The rapid growth in individualized graves and markers is evident in Père-Lachaise. While in 1806, only nineteen individual gravestones were laid, from 1814 to 1830, 30,000 (1,879 per year) were put in place.[10] Hereditary rights to grave sites led to the creation of elaborate family tombs. 'The bourgeoisie, which had acquired political power', Michael Ragon has observed, 'now manifested through its tombs its own dynastic ambitions. It was no longer the soul that was indestructible, but the family, the name.'[11]

American cemeteries differed in important ways from the necropolises spreading throughout Europe. Many of the early settlers took their Protestant traditions with them from England. In Puritan New England, burial, when not in family plots on private land, was in churchyards modelled after the English prototype

commemorated in Thomas Gray's well-known 'Elegy Written in a Country Churchyard'. While always suspicious of graven images, Puritan gravestones display remarkable designs whose simplicity and geometrical precision create considerable aesthetic elegance.[12] The most important contribution America made to the history of cemeteries grew out of the Rural Cemetery Movement. Though inspired by the English garden tradition, the rural cemetery was actually prefigured in nineteenth-century France. The Decree of Prairial prescribed requirements that would transform cemeteries into gardens: 'Trees and shrubs will be planted, with appropriate precautions so as not to interfere with the circulation of air.' Père-Lachaise 'was conceived as a sort of Elysian fields or rolling English garden in which beautiful monuments were dominated by greenery'.[13] In the open spaces of America, agrarian traditions influenced the design of garden cemeteries in ways that still shape the landscape of death.[14] The cultivation of nature in new cemeteries provided a setting in which to remember the dead and instruct the living.

The Rural Cemetery Movement began in Cambridge, Massachusetts, in 1831. Speaking at the dedication of Mount Auburn, Justice Joseph Stom stressed this pedagogical purpose: 'Our cemeteries … may be made subservient to some of the highest purposes of religion and human duty. They may preach lessons, to which none may refuse to listen, and which all must hear. The cemetery has become a school of religion and philosophy.'[15] While the lessons taught in this school vary from time to time and place to place, they seek to educate survivors in the art of living rather than the art of dying. The dead are remembered so that we might live better lives.

The natural setting of rural cemeteries served purposes other than moralizing. The rise of the Rural Cemetery Movement took place at the same time that nineteenth-century Romanticism was flourishing in the United States and Great Britain. For the Romantics, nature was not only tinged with nostalgia but also harboured the possibility of experiencing the Sublime. The Sublime, as Kant famously maintained, is a 'negative pleasure' which is simultaneously attractive and horrifying. Nature, of course, is not always tranquil, for it sometimes unleashes uncontrollable forces that are as appealing as they are frightening. Paradoxically, the source of attraction and repulsion is the same: the prospect of losing one's self in the immensity of death. No-one lived and expressed the sublimity of death more completely than Edgar Allan Poe. His unsettling tale 'MS. Found in a Bottle' concludes with a vision that is exhilarating in its terror:

> Oh, horror upon horror! – the ice opens suddenly to the right, and to the left, and we are whirling dizzily, in immense concentric circles, round and round the borders of a giant amphitheatre, the summit of whose walls is

lost in the darkness and the distance. But little time will be left to me to ponder upon my destiny! The circles rapidly grow small – we are plunging madly within the grasp of the whirlpool – and amid a roaring, and bellowing and thundering of ocean and of tempest, the ship is quivering – oh God! and – going down![16]

This is the abyss that opened and could not be closed in the twentieth century.

Displacement

For the past several years, I have lived part-time in New York City. As I gaze out my window at the posh brownstones and high-rise apartments to which people who spend their days in front of computer screens in a world turned virtual return for the night, my thoughts often turn to death. What will happen to the eight million people in New York City when they die? Will they be cremated and their ashes scattered? Will they be buried and, if so, where? The cemeteries, which once were on the outskirts of the city, are, like the landfills, full. Where do remains now remain? Does it matter any longer?

In the city, *place* is transformed into the *space* of anonymous flows. As technologies change first from steam to electricity and then to information, currents shift, but patterns tend to remain the same. Mobility, fluidity and speed intersect to effect repeated displacements in which everything becomes ephemeral, and nothing remains solid or stable. Baudelaire first recognized the intimate relationship between the tempo and rhythm of the modern metropolis and the aesthetic of modernism. 'By "modernity"', he explained, 'I mean the ephemeral, the fugitive, the contingent, the half of art whose other half is the eternal and the immutable.'[17] Baudelaire's prescient observation not only captures the novelty of the art of his era but effectively describes the process of transvaluation which lies at the heart of modernism. In modernity, truth, beauty and goodness, no longer associated with timelessness and permanence, emerge and pass away in the ceaseless flux of temporality. In philosophical rather than aesthetic terms, becoming displaces being as the locus of reality and authenticity.

The infatuation with becoming issues in the cult of the new, which defines both modernity and modernism. The cultivation of the new simultaneously reflects and reinforces the economic imperative of planned obsolescence. In the modern world, what is not of the moment, up to date, *au courant* is as useless as yesterday's newspaper. The energy fuelling modernity, as Joseph Schumpeter observed long ago, is 'creative destruction' and, I would add, destructive creation. The new affirms itself in and

through the negation of the old. The work of art, like the fashionable dress or the new model, is dated as soon as it appears. The only thing that can be repeated is the new itself; everything else is disposable. When the mobility, fluidity and speed of becoming displace the immutability, security and permanence of being, everything and everybody become terminally unsettled. Modernism's inversion of values is not limited to canvas and page but transforms the very fabric of human life. In this new world, to be is to be on the move even if origin and destination remain uncertain. Movement without end creates a condition of nomadism in which exile is no longer alienation, which must be overcome. On the contrary, mobility – physical, psychological, social and economic – becomes the pulse of life. The longing for permanence and attachment to place, by contrast, become marks of inauthenticity symptomatic of the inability to keep up. Such desire is, for many, fraught with suspicion inasmuch as all soil seems stained with blood.

When to be is to be on the move, speed eventually becomes an end in itself. The difference between modernity, which is inseparable from industrialism, and post-modernity, which is inseparable from informationalism, is the difference between fast and faster. What distinguishes the present from the recent past is not so much change as the acceleration of the rate of change. Acceleration accelerates until it reaches a tipping point where more becomes different. When currents circulating through the space of flows speed up, everything solid melts away. Speed renders life ever more transient and thus increasingly ephemeral. The proliferation of information and telematic technologies in infinitely complex networks creates the new domain of cyberspace, where the realities that are the 'substance' of our lives appear to dematerialize until they become virtual.

As the flow of virtual realities becomes global, cyberspace simultaneously completes and, in a certain sense, reverses transformations begun by telephonic and televisual technologies. Unlike previous spaces, cyberspace is a placeless place in which so-called real time is no longer temporal yet not quite eternal. When in cyberspace, I am no place but not exactly nowhere; it is as if I were dwelling in an elsewhere, which, paradoxically, is present even if not here-and-now. Never past or future, 'real' time is a strange now that is virtually omnipresent.

The placeless place and timeless time of cyberculture form the shifty margin of neither/nor, which, in Don DeLillo's apt phrase, remains 'outside the easy sway of either/or'.[18] In this 'netherzone',[19] 'reality' is neither living nor dead, material nor immaterial, here nor there, present nor absent, but somewhere in between. Understood in this way, cyberspace is undeniably spectral. The virtual realities with which we increasingly deal are ghostly shades that double but do not repeat the selves we are becoming.

The spectre of cyberspace and its enabling technologies provoke conflicting responses. While many people regard cyberspace as a threat to everything they hold dear, others believe it harbours unprecedented possibilities. What makes digital technologies so horrifying is the fear of losing everything deemed human: bodily being, material reality, face-to-face contact, personal relations, genuine community – in short, *real presence*. From this point of view, 'real' time negates 'real' presence. As change accelerates and technology threatens to spin out of control, a growing number of people fear that the truly human being is becoming a thing of the past.

For others, by contrast, the disappearance of the human brings hope rather than despair by holding out the promise of the post-human condition, which will overcome the limitations of life as we have known it. Far from destroying life, new information and telematic technologies, some argue, create the prospect of new life forms, which will overcome death. This pervasive tendency in contemporary culture suggests that Ariès' central claim about our own time is simply wrong. 'When people started fearing death in earnest', he maintained, 'they stopped talking about it, starting with the clergymen and doctors; death was becoming too serious.'[20] There is no doubt that what Ariès described as 'the medicalization of death' has led to the removal of dying and the dead from everyday life. For modern medicine, death is regarded as a failure better kept out of sight. Furthermore, the nomadism of contemporary life makes it more difficult for families to care for the elderly and dying. As often as not, hospitals and healthcare facilities are places people go to die rather than to heal or be cured. The absence of dying and the dead, however, should not be mistaken for the absence of death. Far from excluding death, contemporary culture is obsessed with it. Nowhere is this preoccupation more evident than in the techno-fantasies of modern science.

Science and technology, of course, promote a variety of strategies for denying death. A growing number of people are persuaded that genetic engineering and computer technology promise to make the ancient dream of immortality a reality. Having 'decoded the book of life', it seems a small step to reprogram the human organism in ways that make it invulnerable to disease and, eventually, to death itself. If living bodies cannot be redesigned, they can be cloned. Cloning is as close to the resurrection of the body as science is likely to get. For some true believers, techno-fantasies lead to a techno-gnosticism in which bodily existence is left behind and materiality overcome. From ancient Platonic and Gnostic dualism to Descartes' split between mind and body, the essentially human has been associated with the mental and immaterial rather than the bodily and material. In popular cyber-fantasies, the body appears to be nothing more than 'meat', which must be 'dropped' in order to move to a 'higher' level of being. This vision of the future is an extension of the ephemeralization of life generated by the speed of network culture. As acceleration

rapidly approaches escape velocity, evolution migrates from carbon to silicon.

Appearances to the contrary notwithstanding, these predictions are not the wild fantasies of raving fanatics but the assessments of respected scientists. The award-winning author and distinguished software engineer Ray Kurzweil has gone so far as to declare: 'There won't be mortality by the end of the twenty-first century.' Kurzweil anticipates a future in which 'brain-porting technology' will allow identity to evolve in a mind file until we become software rather than hardware.[21] For Has Moravec, Director of the Mobile Robot Laboratory at Carnegie Mellon University, Kurzweil's vision points towards a shift from the human to the hyperhuman in which 'mere machines' become 'transcendent minds'. These 'superintelligences' transcend the body as well as the material conditions of our existence. Without a trace of irony, Moravec waves 'Bye Bye Body' and projects brains in vats which, he believes, will free us from the constraints under which we now suffer.[22]

The fears and hopes provoked by science and technology reflect the difficulty of sustaining the tensions inherent in cyberspace and network culture. The interplay of neither/nor all too quickly slips back into the easy sway of either/or: either dead or living, material or immaterial, body or mind, organism or machine, present or absent, real or virtual … In a world in which boundaries that long seemed fixed have become permeable membranes through which apparent opposites circulate, alternatives articulated by every either/or are unsustainable. The fears of techno-phobics are as fanciful as the hopes of techno-gnostics. We can no more avoid the changes wrought by informatics and telematics than we can drop bodies that continue to matter. The inescapable spectres haunting our worlds mark and remark the netherzone in which we are destined to dwell.

Living Dead

Cemeteries are where I go to commune with 'my' ghosts. The journey to the cemetery is always solitary, even when I am with the people who are closest to me. In the graveyard, the we is dispersed and the I stripped bare. Since death, like disease, cannot be shared, I must always die alone. The solitude of the cemetery, however, is not precisely the lack of community; rather, it is what Maurice Blanchot has called 'the unavowable community'. Citing his dead friend Georges Bataille, Blanchot described this unavowable community as 'the negative community: the community of those who have no community'.[23] In the cemetery, *we are together as alone in a community without community*. In the solitary confinement of this negative community, however, I discover that I am never merely myself, but am always possessed by ghosts, who, though other,

nonetheless make me who I am and am not. The dead never simply disappear but live on by displacing those who come after them. The graveyard is where we keep the dead *alive as dead*. For those who venture thoughtfully into deadly precincts once deemed holy, the cemetery becomes a place of memory and meditation: memory of what the dead once were and meditation on what I soon will be.

As I ponder the graves of the ghosts who have shaped the world I mistakenly call 'my own' and, who, in ways I do not fully understand, continue to speak through me, I am struck more by their differences than by their similarities. In some cases, the story of the grave fits the story of the life; in other cases, it does not. Last wishes, it seems, are as often denied as fulfilled. Many of the tombs and markers figured in these pages express the needs of survivors more than the desires of the dead.

The least surprising graves are those that seem to be consistent with the lives commemorated. More than any thinker in the twentieth century, Martin Heidegger developed an entire philosophy around the confrontation with death. For Heidegger and generations of existentialists who followed him, human authenticity was impossible apart from 'being-towards-death'. Only in the face of death do I become aware of my unique individuality, for which I must take complete responsibility. While never abandoning the individual as such, in his late philosophy Heidegger became obsessed with recovering our primordial relationship with what his follower Paul Tillich eventually would label 'the ground of Being'. While Heidegger did not always explain the theological implications of his work, religious concerns were never far from his mind. When he died on 26 May 1976 at the age of 87, he was buried in the church of St Martin in the village of Messkirch, where he had been born and baptized. A Catholic mass, presided over by his nephew Heinrich, who was a priest, was held in his memory, and burial followed prescribed church ritual. As his biographer Hugo Ott observed:

> He wanted to be buried in his native soil, in the place where he was really at home, where the remembrance of his ancestors was rooted, where the skies looked down upon a land that is free and open and radiant, whose harsh austerity conceals a kind of gaiety. He wanted to return to the place whence he had started out, the land of his fathers, the source of his being.[24]

Death, it seems, was the homecoming for which Heidegger always longed but which he never found in life.

While Heidegger is the philosopher who thought about death most radically in the twentieth century, Kierkegaard is the one who pondered it most thoroughly in the

nineteenth. Kierkegaard's relationship to Protestantism was as conflicted and complicated as Heidegger's to Catholicism. For Kierkegaard, death was the great 'leveller' in relation to which everyone is equal:

> And if you go out there [to the cemetery] earlier in the morning, when the sun peeps vivaciously through the branches, you will find everything so nicely decorated. The small families have their own plot for themselves, approximately the same size. To be sure, in life it happens that a family is forced to stint, but in death all must do so. In life an influential man can manage to spread himself around, but in death all must restrict themselves. Yet there is a minor distinction, like a droll reminder of the distinction, which was so enormous in the world; if there is a distinction here, it is a matter of inches …[25]

Death, Kierkegaard believed, is 'a good dancing partner' because it is a constant reminder that differences, which seem so important in life, are at the end of the day indifferent and inconsequential.

At the time of his death on 11 November 1855, Kierkegaard was engaged in a fierce attack on the Danish state church, prompting heated debate in the press. Far from being the Christian country it claimed to be, Denmark and its official Lutheranism, Kierkegaard insisted, represented the opposite of true faith. Priests, who were civil functionaries, and citizens, who were Christian by birth, actually betrayed the religion of Jesus. Though he was only 42 years old at the time of his death, Kierkegaard saw the hand of providence in the illness that took his life. Having struggled 'to reintroduce Christianity into Christendom', he believed that his mission was complete and was prepared to die. When the decision was made to hold the funeral in Vor Frue Kirke in the heart of Copenhagen and to have the Dean of the Cathedral officiate, Kierkegaard's defenders and detractors were both outraged. A crowd spilled over into the streets and boisterously followed the procession to the Assistents Kirkegaard, then at the edge of the city, where Kierkegaard was buried in the family plot. At the graveside, conflict could no longer be contained; Henrik Lund, Kierkegaard's nephew, attacked the presiding priest by defiantly reading from the Book of Revelation and quoting the most devastating passages from his uncle's final attack on the church. Longstanding family tensions led Kierkegaard's brother, Peter, to refuse to mark the site of his burial for twenty years, by which time it was too late to be sure exactly where the body lay. That is why the marble slab bearing Kierkegaard's name is not set in the ground but leans somewhat precariously against the tombstone. The inscription on the family monument is in marked contrast to the acerbic wit and biting irony of one of

Christianity's greatest thinkers and writers. The lines are drawn from Hans Adolph Brorson's *Halleluja! Jeg har min Jesum funden*:

> A little time and I have won.
> Then all strife at once is done.
> Then I may rest in rosy halls
> And ceaselessly with my Jesus speak.

Fourteen years before Kierkegaard's death, the intellectual foe without whom he never would have become a philosopher died in Berlin. When Hegel succumbed to death on 14 November 1831 at the age of 61, he was Germany's leading intellectual celebrity and was drawing hundreds of students to his lectures. In post-Napoleonic Germany, Hegel had become more than a university professor; for many, he symbolized the way to negotiate the perilous passage from a fractious past to the modern world. Though it is impossible to be certain, Hegel's death probably was caused by the cholera epidemic that swept Berlin at the time. Several of his influential friends traded on his reputation and political connections to get the Prussian authorities to suspend a law requiring victims of cholera to be buried in a special cemetery.[26] On 16 November, a huge procession of university colleagues, politicians, dignitaries and students followed the wagon with Hegel's body to the Dorothea Cemetery, where he, unlike many others, was buried in accordance with his wishes, next to Johann Gottlieb Fichte. In addition to being a fellow Idealist philosopher, Fichte had been the first Rector of the University of Berlin, which had been founded in 1810 and which remains the model for most universities in Europe and America today. In his eulogy, Philipp Konrad Marheineke, a theologian who was then the University's Rector, went so far as to compare Hegel to Christ:

> In a fashion similar to our savior, whose name he always honored in his thought and activity, and in whose teaching he recognized the deepest essence of the human spirit, and who as the son of God gave himself over to suffering and death in order to return to his community eternally as spirit, he also has not returned to his true home and through death has penetrated through to resurrection and glory.[27]

Today, Hegel's body rests next to that of his wife Marie. Two rows over, Bertolt Brecht, whose Marxism would have been impossible without Hegel, is buried.

Shortly before my last visit to Hegel's grave, someone told me that Dietrich Bonhoeffer, the Protestant theologian and existential ethicist who was executed for his

participation in the plot to assassinate Hitler, is also buried in the Dorothea Cemetery. Though I searched the churchyard thoroughly, I could not find Bonhoeffer's grave. As I was about to leave, I noticed an elderly man, with head bowed, holding a watering can and standing near a grave covered with flowers. Reluctant to disturb him, I waited until he moved and then approached him. In faltering German, I asked if he knew where Bonhoeffer was buried. Pointing to the far side of the cemetery, he slowly led the way. As we walked, he told me that his wife of over 50 years had recently died and that he no longer wanted to live. 'Loneliness', he whispered, 'is worse than death.' Even if my German were better, I would not have known how to respond, because I knew that he was right. When we reached what I expected to be Bonhoeffer's grave, the old man silently pointed to the name etched in stone. It was a memorial stone that marked the missing body, which, I later learned, has never been recovered. As I thanked him, he turned and walked back to his wife's grave.

The most important philosophers who prepared the way for the modern and post-modern worlds were decisively influenced by Kant. During the last quarter of the eighteenth century, Kant, teaching and writing in the remote outpost of Königsberg (now Kaliningrad, Russia), developed a critical philosophy that has recast the intellectual, social and political landscape in the last two hundred years. A modest man, Kant wanted a small private funeral with no viewing. His wish was denied. After he died, his head was shaved and a mould taken of it; his emaciated body was then put on display for sixteen days in his home, where a steady stream of visitors, some returning two or three times, came to view the corpse. J. H. W. Struckenberg reported that

> there was a strong desire to secure mementos of the great Kant. His silver hair was braided into rings and sold; and the demand for these souvenirs was so great that one of his biographers suspects that there was a miraculous increase of his hair, as in the case of the relics of saints, and that more was sold than ever adorned his head. At the sale of his effects, trifles, such as a tobacco-pouch, which was useless and used probably for twenty years, brought large sums of money.[28]

The Governor of the province, city officials, faculty members, students and even military officers joined in a procession to transport Kant's body from his home to the Königsberg Dom, where it was placed between a marble bust of him and a collection of his books. On his coffin were inscribed the words 'Cineres mortales immortalis Kantii'. After the ceremony, his body was placed in the Professors' Crypt until 1809, when it was moved to allow for the construction of a promenade. In the following decades, Kant's grave was so neglected that some people openly questioned whether it

really marked the location of his body. In 1881, on the hundredth anniversary of the publication of the *Critique of Pure Reason*, his remains were transferred to a massive memorial that looks more like an ancient Greek temple than a monument to the philosopher who, as much as any other, was responsible for the emergence of modernity.

The stories of final wishes denied are as numerous as those of final wishes fulfilled. Sometimes, the incongruities are more illuminating than the consistencies. It is remarkable how persistent religion remains in death – even for those who devoted their lives to criticizing it: Nietzsche, finally succumbing after years of madness, buried beside his father in the churchyard in Röcken where the elder Nietzsche had been a Lutheran pastor; Descartes taking the Catholic Eucharist in Protestant Sweden, shortly after contracting the disease that would kill him; Charles Baudelaire, author of the infamous *Les Fleurs du mal*, dying in his mother's arms, recovering consciousness long enough to ask for the last sacraments; Antonin Artaud, creator of the theatre of cruelty, buried in a tomb adorned with a large Christian cross. Only a few sought anonymity in death: Joseph Beuys had his ashes scattered in the North Sea; Friedrich Engels's ashes were scattered, according to his instructions, in the sea along the coast of Eastbourne, England; Albert Einstein's remains were dispersed at a secret location, though his brain was preserved for scientific research; Georgia O'Keeffe's ashes were spread in the New Mexico desert near her studio in Abiquiu; Percy Bysshe Shelley's ashes were scattered at an unknown location, but his heart was saved from his funeral pyre in Viareggio and is buried with his wife, Mary, in Bournemouth, Dorset.[29]

It is remarkable how few of these leading writers, artists and philosophers prepared epitaphs for their gravestones. In some cases, survivors selected a few lines from the works of the deceased to serve as their final words; in other, words alone were insufficient, and grander memorials were created. It is clear, however, that survivors need such monuments more than the dying want them. The awareness of approaching death tends to bring a sense of humility and proportion even among the great. Kant was not the only one whose wish for a modest burial and grave was denied by well-intending but over-zealous followers. Karl Marx's grave in London's Highgate Cemetery was ill kept until 1956, when a large marble block with a massive cast-iron form of his head was erected on the site. In 1966, the bodies of James Joyce and his wife, Nora, were moved to permanent plots in Zurich's Fluntern Cemetery. Fifteen years later, a statue of Joyce sitting cross-legged and smoking a cigarette was placed beside the grave. One of the most poignant memorials is dedicated to Virginia Woolf. On 28 March 1941, Woolf, distraught by the War and fearing she was 'going mad again', drowned herself in a river close to her studio. Her body was not recovered for three weeks and, after an official inquiry into the cause of death, she was cremated. Her

husband, Leonard, scattered her ashes under one of two elm trees in their garden, which they had affectionately named 'Virginia' and 'Leonard'. Leonard marked the site with a line from her novel *The Waves*: 'Against you I will fling myself unvanquished and unyielding, O Death!'[30] Today, there is a plaque on the nearby garden wall:

> The ashes of Leonard and Virginia Woolf, who lived in this house from 1919 until their deaths, were scattered under the great elm tree. In 1972 the plaque in Virginia's memory, which Leonard had placed there, was moved from the elm to this more permanent position. At the same time the bust of Leonard Woolf and this plaque in his memory were placed here. The head of Virginia was modeled by Leonard. That of Leonard was modeled by Charlotte Heuer and placed here together with these plaques by Trekkie Parsons.

The pensive eyes of this remarkable sculpture are as penetrating as the discerning words which Virginia Woolf left behind.

The most bizarre memorial is English utilitarian philosopher Jeremy Bentham's 'Auto Icon', located in the lobby of University College London. Bentham left detailed instructions in his will for the preservation and display of his body. While such exhibition of the corpse is not unprecedented – one thinks of Christian saints and martyrs or Lenin's body preserved in Red Square – this is the only instance of which I am aware in which the individual rather than his or her followers arranged the morbid spectacle. The relevant section of Bentham's will appears on the glass case protecting his reconstructed body:

> My body I give to my dear friend Doctor Southwood Smith to be disposed of in a manner hereafter mentioned and I direct that … he will take my body under his charge and take the requisite and appropriate measures for the disposal and preservation of several parts of my bodily frame in the manner expressed in the paper annexed to this my will and at the top I have written 'Auto Icon.' The skeleton he will cause to be put together in such a manner as that the whole figure may be seated in a chair usually occupied by me when living in the attitude in which I am sitting when engaged in thought in the course of writing. I direct that the body thus prepared shall be transferred to my executor, he will cause the skeleton to be clad in one of the suits of black occasionally worn by me. The body so clothed together with the chair and the staff in my later years borne by me he will take charge of and for containing the whole

apparatus he will cause to be prepared an appropriate box or case … If it should happen that my personal friends and other disciples should be disposed to meet together on some day or days of the year for the purpose of commemorating the Founder of the greatest happiness, system of morals and legislation, my executor will from time to time cause to be conveyed to the room in which they meet the said box or case in which the contents therein be stationed in such a part of the room as the assembled company shall meet.

In the 1980s, Bentham's head was removed, put in the University College safe and replaced with a wax face modelled by Jacques Talrich. In a twist Bentham doubtless would have relished, a replica of his wax head is mounted over the bar in the nearby Jeremy Bentham Pub.

While Bentham was one of the leading representatives of the British philosophical tradition, the founder of modern philosophy, who began what eventually became known as Continental Rationalism, suffered a fate in death no less strange than the history of the 'Auto Icon'. If Descartes identified the essence of human being with the mind's cognitive activity, the body, he insisted, was no more than an 'extended thing' (res extensa), more of a machine than a living organism. At the time of his death, Descartes was in Sweden tutoring the impressionable Queen Christina. Many Swedish Lutherans blamed him for her conversion to Catholicism and eventual abdication. Descartes fell ill with pneumonia on 2 February 1650 and died nine days later. Shortly after being stricken, he attended mass and received the Eucharist. When he died, the Queen wanted to arrange a large state funeral and bury Descartes in Stockholm's largest church. But his close friend Hector Chanut knew he would not have wanted to be buried in Protestant soil and received her consent for a Catholic ceremony and burial in unconsecrated ground in a cemetery for unbaptized infants. This internment, however, proved to be merely the first step in what one commentator aptly labelled a 'burlesque necrology'.[31] In 1666, the Treasurer-General of France, D'Albert, received permission from the Swedish government to return Descartes' body to Paris at his own expense. When the body was exhumed, the French Ambassador was allowed to cut off the right forefinger from the decomposed corpse. The remains were put in a 2½-foot brass coffin and shipped by way of Copenhagen to France but did not arrive until January 1667. The coffin was buried in the Eglise de Saint Paul and, six months later, was moved to the Abbey of Saint Etienne-du-Mond, where it was kept until the church was closed in 1792. Descartes' remains were moved once again to the Jardin Elysée des Monuments Français and, in 1819, were transferred to the Chapel of the Sacré Coeur in Saint Germain-des-Prés, where they can still be found.[32]

Since the original tombstone on this site was mislaid at least twice, the precise location of Descartes' 'final' grave remains uncertain. Even stranger than Descartes' wandering body, however, is the fate of his skull. When his remains were moved to France in 1666–7, his skull was kept in Sweden until 1822:

> It seems that a captain in the Swedish guards who was present at the original exhumation removed the skull and replaced it with another, and the skull was resold several times before coming into the hands of Berzelius, who in 1821 offered it to Cuvier, and this skull is now to be found in the Musée de l'Homme in Palais de Chaillot.[33]

In spite of attempts to authenticate the skull, it is most unlikely that it was Descartes'. It is, to say the least, hard to imagine his itinerant body offering support for his philosophical principles. Far from being immaterial, some of his most devoted followers found his body worthy not only of veneration but of consecration. With displaced bodies and detached skulls floating freely, it is not clear whether, as Descartes believed until the end, reality is rational and thinking is being.

While continuing the tradition of individual graves, cemeteries in America differ in notable ways from churchyards and graveyards in Europe. In Puritan Massachusetts, where I work amid the shadows of many of America's greatest writers, death and nature are braided in ways that can never be untangled. It was, after all, death that drew Henry David Thoreau from the village of Concord into the woods around Walden Pond: 'I went to the woods because I wished to live deliberately, to front only the essential facts of life, and see if I could not learn what it had to teach, and not, when I came to die, discover that I had not lived.'[34] Thoreau knew a lesson I have learned: what you think is, in no small measure, a function of where you think. Surely it is no accident that the Rural Cemetery Movement began in Massachusetts. There is something about the landscape, especially the worn mountains, that made this cemetery design all but inevitable in New England. Nor is it an accident that post-Kantian philosophy and its poetic translation in Romanticism were taking root in Massachusetts at the same time that rural cemeteries were growing. Hegel, Fichte and Schelling, as well as Blake, Wordsworth and Coleridge, make sense in Massachusetts.

Twelve miles up the road from where I live, Robert Frost lies buried in the churchyard of a New England Congregational church that looks like it was copied from a Norman Rockwell painting. Half a state away, Emily Dickinson is buried in another college town. While Thoreau was my mother's favourite prose writer, Dickinson was her most beloved poet. On a card stuck in the daybook we never recovered, she had written words that continue to haunt me:

Because I could not stop for Death,
He kindly stopped for me;
The carriage held but just ourselves
And Immortality.[35]

By the time of her death, Dickinson had travelled far without leaving the town of Amherst. On 18 May 1886, an obituary written by her sister, Susan, appeared in the Springfield *Republican*:

The death of Miss Emily Dickinson, daughter of the late Edward Dickinson, at Amherst on Saturday, makes another sad inroad on a small circle so long occupying the old family mansion … Very few in the village, except among the old inhabitants, knew Miss Emily personally, although the facts of her seclusion and her intellectual brilliancy were familiar Amherst traditions. As she passed on in life, her sensitive nature shrank from much personal contact with the world, and more and more turned to her own large wealth of individual resources for companionship …[36]

At her funeral, Thomas Wentworth Higginson read from Emily Brontë's 'Last Lines'. Later, recalling the occasion in his diary, he wrote: 'The grass of the lawn was full of buttercups and violet & wild geranium.'[37] Emily's body was carried from the house she rarely left except in her imagination, through the garden and across the meadow to the churchyard, where she was buried next to her parents. As my mother's body was lowered into the ground, I silently recited the lines she had copied in her memory book from Emily Dickinson.

Farther to the east on the outskirts of Cambridge, where I studied German Idealism, British Romanticism and American Transcendentalism, Thoreau, Ralph Waldo Emerson and Nathaniel Hawthorne share Concord's Sleepy Hollow Cemetery. In earlier years, Hawthorne had lived in a cottage at Tanglewood and, with Melville, roamed the mountains surrounding my home. Even though Thoreau had broken with the church, Emerson insisted that the funeral be held in the First Parish Church, where he delivered a lengthy eulogy. When Hawthorne (1864) and Emerson (1882) joined Thoreau in peaceful Sleepy Hollow, one of the most important eras in American cultural history drew to a close but did not come to an end.

Nowhere are the lessons taught by the haunting stories associated with the graves assembled in *Grave Matters* clearer than in the poignant deaths of Edgar Allan Poe and Herman Melville. Poe, of course, was obsessed with death and terrified of being buried alive. His tale 'The Premature Burial' begins with the narrator reflecting:

To be buried while alive, is, beyond question, the most terrific of these extremes which has ever fallen to the lot of mere mortality. That it has frequently, very frequently, so fallen, will scarcely be denied by those who think. The boundaries which divide Life from Death, are at best shadowy and vague. Who shall say where the one ends and the other begins?[38]

The shadowy boundary between life and death is the netherzone, where Poe's ghosts – as well as our own – ceaselessly wander. Poe was haunted by spectres until the day he died. His death on 7 October 1849 is as shrouded in obscurity as the tales he spun. Distraught by personal and professional failures, he left New York City for Philadelphia on 30 June of that year. No-one had heard from him for ten days when he burst into the editorial offices of the *Union Magazine*. His friend, the editor John Sartain, reported what transpired:

> 'I was on my way to New York on the train,' he said to me, 'when I heard whispering going on behind me. Owing to my marvelous power of hearing, I was able to overhear what the conspirators were saying. Just imagine such a thing in this nineteenth century! They were plotting to murder me. I immediately left the train and hastened back here again. I must disguise myself in some way; I must shave off this mustache at once. Will you lend me a razor?' … Now he began to talk in the wildest nonsense, in the weird, dramatic style of his tales. He said he had been thrown into Moyamensing Prison for forging a check, and while there a white female form had appeared to him on the battlements and addressed him in whispers.[39]

In all likelihood, Poe's hallucinations were induced by his excessive drinking. After several weeks of recuperation in Richmond, he again headed north to Baltimore. 'What happened next', David Sinclair has explained, 'is a mystery.' One story places Poe in Philadelphia, tired and ill and telling his friends that he was on his way to New York. The only solid evidence, however, comes from Baltimore on 3 October, when a Dr Snodgrass received a hurriedly scrawled note:

> Dear Sir, – There is a gentleman, rather the worse for wear, at Ryan's 4th Ward polls, who goes under the cognomen of Edgar A. Poe, and who appears in great distress & says he is acquainted with you, and I assure you, he is in need of immediate assistance.

Yours, in haste,
Jos. W. Walker[40]

Snodgrass came quickly and, finding Poe unconscious, took him to Washington College Hospital. During the following days, Poe suffered violent *delirium tremens*, finally dying on 7 October either from alcohol poisoning or in a diabetic coma. The funeral, which took place the next day in the Presbyterian Church in Baltimore, went virtually unnoticed. A stranger called Colonel J. Alden Weston was passing and later published the following account in the *Baltimore Sun*:

> The burial ceremony, which did not occupy more than three minutes, was so cold-blooded and unchristianlike as to provoke on my part a sense of anger difficult to suppress. The only relative present was a cousin (a noted Baltimore lawyer), the remaining witnesses being from the hospital and the press. After these had left I went to the grave and watched the earth being thrown upon the coffin until entirely covered and then passed on with a sad heart and the one consolation that I was the last person to see the coffin containing all that was mortal of *Edgar Allan Poe*.[41]

The grave was marked by nothing other than the number 80, which the sexton placed on the site.[42]

While Poe dreaded premature burial, Melville was effectively buried alive in the last years of his life. After completing *The Confidence Man* in 1860, he moved from the family farm, Arrowhead, in Pittsfield, Massachusetts, to New York City, where he lived until his death in 1891. Concerned about his persistent propensity for melancholy, family members arranged a job for him as a District Officer in the Custom House. The position was less impressive than the title. Nonetheless, the family was encouraged by the effect of the change: "'Herman's health is much better," his mother wrote to Catherine Gansevoort on March 11, 1867, "since he has been compelled to go daily to attend to his business."[43] Melville was far less sanguine about his condition. After the suicide of his eighteen-year-old son Malcolm, he withdrew deeper into himself and, like Emily Dickinson, became even more reclusive. Though he continued to write, his best work was behind him. As he lost interest in the world, the world lost interest in him. By the time he died on 28 September 1891, many young writers did not even know he had still been alive. A small funeral, held in the Melville home, was followed by burial next to Malcolm in Woodlawn Cemetery in the Bronx. The *New York Times* obituary referred to the dead writer as 'Henry' Melville, and one of the other notices of his death listed his name as 'Hiram' Melville.

Thus the two greatest writers America has produced died alone in utter obscurity: one face down and unconscious in a drunken stupor, the other wrapped in melancholy and forgotten by a country that didn't even know his name.

Impossibility of Dying

As I write these words sitting in my living room beneath the grave rubbings of my ghosts, I look out on the same snow-covered mountains Melville pondered while writing *Moby-Dick*. For longer than I can remember and for reasons I do not understand, I have assumed that the colour of death is *white*. Perhaps this is why when I started reading Poe and Melville, I did not experience a sense of discovery as much as one of rediscovery, with all the troubling marks of the uncanny. Staring into the white noise of eternal silence, Melville immortalized whiteness in the sea monster from which we have come and to which we will return:

> Is it by that indefiniteness it shadows forth the heartless voids and immensities of the universe, and thus stabs us from behind with the thought of annihilation, when beholding the white depths of the milky way? Or is it, that as in essence whiteness is not so much a color as the visible absence of color, and at the same time the concrete of all colors; is it for these reasons that there is such a dumb blankness, full of meaning, in a wide landscape of snows – a colourless, all-color of atheism from which we sink? And when we consider that other theory of the natural philosophers, that all other earthly hues – every stately or lovely emblazoning – the sweet tinges of sunset skies and woods … all these are but subtle deceits, not actually inherent in substances, but only laid on them from without. So that all deified Nature absolutely paints like the harlot, whose allurements cover nothing but the charnel-house within … pondering all of this, the palsied universe lies before us like a leper; and like wilful travelers in Lapland, who refuse to wear colored and coloring glasses upon their eyes, so the wretched infidel gazes himself blind at the monumental white shroud that wraps all the prospect around him. And all of these things the Albino was the symbol. Wonder ye then at the fiery hunt?[44]

To hear these haunting words – really to *hear* them – 'one must have a mind of winter,' cultivated through long years of restless reflection. Wallace Stevens was one of the few who had such a mind and was generous enough to share it in his memorable

poem 'The Snow Man', which ends:

> For the listener, who listens in the snow,
> And, nothing himself, beholds
> Nothing that is not there and the nothing that is.[45]

'The nothing that is not there and the nothing that is': what is this nothingness if not the spectre of death?

Death is not merely the end of being but hides within life as its necessary condition. It is, therefore, impossible to affirm life without embracing death. Death, coiled in life, is forever fraught with paradox. Though some time in the future, I undoubtedly will be dead, *dying is impossible*. I am, in Maurice Blanchot's disturbing words, 'prevented from dying by death itself'.[46] I never die because when I am present death is not, and when death is present, I am not. Death always occurs in the blink of an eye – in the *Augenblick, Øjeblik*, instant. With eyes wide shut. Never actually present, death is the presence of a non-presence that is not quite an absence. Forever outside the easy sway of either/or, death is neither present nor absent, here nor there, real nor unreal, but somewhere in between – along the margin, at the border, on the edge. The presence of this non-presence is what makes death unavoidably spectral.

The edge of death that borders life is the horizon that approaches without ever arriving. Paradoxically, death is the future that cannot become present but nonetheless someday will render me past. To die is to cease to be mortal without becoming immortal. This past-that-is-my-future can never be experienced; though I might struggle to imagine it, dying, as well as being dead, is unimaginable. I can no more experience dying than I can be when and where I am not. What makes death so dreadful is not my absence but oblivion – the absolute oblivion of *being forever forgotten*. As if I had never lived. Death and forgetting are tied in a knot that can never be undone. I am, as Blanchot insists, 'awaiting oblivion':

> 'Could it be that to forget death is actually to remember it? Would forgetting be the only remembrance commensurate with death?' – 'Impossible forgetting. Each time you forget, it is death that you recall in forgetting.' Forgetting death, meeting the point where death sustains forgetting and forgetting gives death, turning away from death through forgetting and from forgetting through death, thus turning away twice to enter the truth of the detour. The initiative of forgetting in motionless waiting.[47]

It is in response to the dread of oblivion that graveyards are created and gravestones inscribed. Who can honestly say he or she has never wondered whether anyone will visit his or her grave? Though a precious few might remember me for a while, even the rock of ages eventually erodes, crumbles into sand and is scattered by the wind. Though death is never absent, the world does not miss a beat. Wishes to the contrary notwithstanding, cemeteries memorialize forgetting. On the gravestones of others, I read: '*I will be forgotten.*' Yet, if death is oblivion, to forget death is, impossibly, to remember it.

Death is always approaching but never properly arrives; never present, it remains remote in its proximity and proximate in its remoteness. Even when anticipated, death is unexpected:

> Because I could not stop for Death,
> He kindly stopped for me …

Death, it is said, 'comes like a thief in the night'. It is always (a) given – even when a person 'takes' his or her 'own' life. In this sense, death is a gift – perhaps the absolute gift of life. Approaching without ever being (a) present, the gift of death is the future, which keeps life open. Contrary to expectation, the deadly openness of the future creates the space of desire. It is not so much that I desire death as that death is the non-absent absence that engenders desire. Without the remote proximity of death, there would be no desire, and without desire, there is no life. In response to the gift of death, which is the gift of life, I have *nothing* to give in return – *absolutely nothing*. The nothing I have to give is nothing other than the nothing that is not there and the nothing that is. Neither present nor absent, the spectre of death casts the inescapable shade in which life must be lived.

In the photograph, the power of the negative – both literally, as it were, and figuratively – is enacted in a way that draws the viewer into its play of darkness and light. Death, as Roland Barthes insisted, 'is the *eidos*' of the photograph:

> In terms of image-repertoire, the Photograph (the one I *intend*) represents that very subtle moment when, to tell the truth, I am neither subject nor object but a subject who feels he is becoming an object: I then experience a micro-version of death (of parenthesis): I am truly becoming a specter.[48]

In the photograph, I can almost glimpse 'the movement through which whatever disappears keeps appearing'.[49] It is, paradoxically, the fix of the photographic image that allows this movement to appear. The flick of the shutter is the blink of the eye in

which the here-and-now is present as dead-and-gone. The photograph is the death of the thing as well as the person it nonetheless figures. For this reason, every photograph is (a) still-life, or, in the telling French term, a *nature morte*:

> Here the distancing is at the heart of the thing. The thing was there; we grasped it in the vital movement of a comprehensive action – and lo, having become image, instantly it has become the ungraspable, the unreal, the impossible. It is not the same thing at a distance but the thing as distance, present in its absence, graspable because ungraspable, appearing as disappeared. It is the return of what does not come back, the strange heart of remoteness as the life and the sole heart of the thing.[50]

Inasmuch as the photographic image is 'the thing in its absence', which is 'the return of what does not return', it is the unmistakable trace of death. It is this trace that Dietrich Christian Lammerts so effectively captures in his photographs. 'The photograph and the corpse', he suggests, 'both provide a material trace of an absent subjectivity. It is the after-image that returns us to the subject through memory. Perhaps even digital photography is a mode of bereavement. In a certain sense, this can be said of all photography.'

There are other traces of the dead scattered like so many ashes throughout these pages. Not content with images of death, we have also gathered remains of the remains of the dead. At each gravesite, we collected some material – some (grave) matter: dust, dirt, stones, grass, leaves, moss, even mould. We have sealed these remains in small, black film canisters and labelled them to preserve them like relics, which are spectral memorials. They have been opened once, but only once, to photograph. These photographic images of the remains of remains become even more ashen spectres of the spectre of death.

Grave Matters is the story of ghosts that continue to haunt us. The spectral photographs of markers intended to be permanent expose the appearance of the disappearance that is never quite my own. In these *memento mori*, I discern the nothing I will become and always will have been. Death, as Kierkegaard taught us long ago, is not only a 'good dancing partner' but also 'the great leveller'. Gazing into the dust and ashes of these graves and their images, we learn that *nothing – absolutely nothing – lasts*. What Kierkegaard was never able to believe is that the nothingness of death need not necessarily bring in its wake interminable mourning and inevitable melancholy. Hegel understood what Kierkegaard could never accept, that unhappy consciousness need not be the end of life:

But the life of spirit is not the life that shrinks from death and keeps itself untouched by devastation, but rather the life that endures it and maintains itself in it. It wins its truth only when, in utter dismemberment, it finds itself. It is this power, not as something positive, which closes its eyes to the negative, as when we say of something that it is nothing or is false, and then, having done with it, turn away and pass on to something else; on the contrary, spirit is this power only by looking the negative in the face, and lingering with it. This lingering with the negative is the magical power that converts it into being.[51]

Place

Graves matter. It is not just the matter of matter – dust, dirt, stones, grass, leaves, moss, even mould – but the matter of place or its lack. Death forces us to consider our final place in the world – physical as well as social. By the side of the grave, life appears to be a constant flight from or search for place. Even in a world where everything seems to have been displaced, there is a finality to place that cannot be avoided. If one ponders – really ponders – the images gathered in *Grave Matters*, it is impossible not to ask 'What is *my* place in relation to these ghosts? How have they made me what I am? How have I made them what they were not? And after all is said and done, where will I end up?'

It is, of course, easier to leave such questions to others or to address them only near the end – as if we ever know when the end will arrive. But such avoidance or deferral is a mistake, because you cannot live life until you have faced death. Admitting that I could no longer evade the questions I ask others to face, I eventually realized that I could not complete this book without deciding where I will be buried.

Having spent my entire professional life in one place, I know all too well both the delight and the terror that place can breed. If to be is to be on the move, then how can one possibly stay in one place? Movement, however, is complex; all too often, we mistake motion for movement. In graveyards, where *nothing* moves, we can see that many of those who are most mobile sometimes move the least, and some of those who are least mobile move the most. Kant never left Königsberg; Kierkegaard left Denmark but once; Emily Dickinson never left Amherst. These remarkable people did not have to be in motion to move the world because they knew their place.

The place I have lived and worked in for many years is better suited to the nineteenth than to the 21st century. Much of what I have thought and written about the tangled interrelation of the nineteenth, twentieth and 21st centuries would have been impossible without the tensions created by this place. I have been able neither to leave

nor to stay and thus have had to find ways to stay on the move while remaining in place.

One of the strangest anachronisms of this place, which has never really been home, involves death and burial. A perk of tenure where I teach is a burial plot in the College cemetery. Those who know local customs invariably add to their congratulations for receiving tenure words of welcome to the College's society of the dead. While I had long known its location, I had never visited the cemetery until last summer, when I knew the moment I had been avoiding had arrived. Though in the midst of the campus, the graves are secluded by a ring of tall evergreen trees, which muffle surrounding sounds. It is as if the cemetery were a silent void in the midst of bustling activity. As I roamed over the lawn, walking on the remains of the dead, I read the names of colleagues and friends. Others I knew only by reputation or by buildings, lecture halls and classrooms bearing their names. Some of the markers on the graves of spouses were inscribed with the names and birth dates of colleagues with whom I still work. The death date was left blank like an examination question waiting to be answered. Here, stones, which usually guard silence, echo a ceaseless ticking. Though the place is extraordinarily beautiful and reassuringly peaceful, I found it unbearable. It was as if some deranged administrator had convened a faculty meeting that would continue for eternity. I fled in horror. But if not there, where?

In addition to the College cemetery, there are two main public graveyards in town: East Lawn and West Lawn. No church has a cemetery. More intriguing than these well-maintained public cemeteries are old family plots scattered throughout the woods surrounding the town. Some of these graveyards are marked by elaborate wrought-iron fences, while others have virtually disappeared beneath bushes and trees. When roaming the woods, I have discovered several small, forgotten cemeteries and even an occasional solitary gravestone in the midst of leaves and weeds.

There is another place close to the edge of town that few people know and where no-one from the College is buried. Even though it is only a mile from where I live, it took me twenty years to notice it and even longer to visit it. This cemetery is tucked behind a farm at a graceful bend in the Green River. It is called South Lawn and was established in the eighteenth century. The oldest stone I have found is dated 1778. While far from town, this place is not silent; the sound of the rushing river always fills the air. This cemetery is also encircled by tall evergreens. But there are gaps, and through them you can see open fields and, more importantly, mountains. This cemetery lies near the foot of Mount Greylock.

During the winter months when Melville was completing *Moby-Dick* at Arrowhead, he spent long hours gazing at Mount Greylock through his window. With his irrepressible mind of winter, he saw in the snow-covered mountain the image of the white whale. One year later, he published *Pierre or, the Ambiguities*, which he

prefaced with the words 'To Greylock's Excellent Majesty':

> In old times authors were proud of the privilege of dedicating their works to Majesty. A right noble custom, which we of Berkshire must revive. For whether we will or not, Majesty is all around us here in Berkshire, sitting in a grand Congress of Vienna of majestical hill-tops, and eternally challenging our homage. But since the majestic mountain, Greylock – my own more immediate sovereign lord and king – hath now, for innumerable ages, been the one grand dedicatee of the earliest rays of all Berkshire mornings, I know not how his Imperial Purple Majesty (royal-born: Porphyrogenitus) will receive the dedication of my poor solitary ray. Nevertheless, forasmuch as I, dwelling with my loyal neighbors, the Maples and the Beeches, in the amphitheater over which his central majesty presides, have received his most bounteous and unstinted fertilizations, it is but meet, that I here devoutly kneel, and render up my gratitude, whether, thereto, The Most Excellent Purple Majesty of Greylock benignantly incline his hoary crown or no.[52]

What one thinks, I have insisted, is deeply conditioned by *where* one thinks. I suspect that it is no coincidence that the greatest American novel was written at the foot of Mount Greylock. Though I know I would think, write and live differently in another place, I do not know whether I have chosen this place or it has chosen me.

I will be buried at the edge of the cemetery which lies in the shadow of Mount Greylock, on the edge of town. I have always believed that the edge is the only place worth living on and will not give up that belief in death. Along the edge, nothing remains fixed. The only hope I harbour is that the noise of the river will keep me awake so that I can wander with my ghosts and, perhaps, haunt others as they have haunted me.

Of all the words I have written, none has been more difficult than these. I do not know when it will end or how it will end – no-one does; but I do know where I will end. Knowing that place allows me to know my place in a way that makes it possible to go on – at least for a while. If life is affirmed by embracing rather than avoiding death, the gravity of darkness might become the levity of light. What we must learn and relearn is the delicate art of holding on by letting go. This is the lesson my ghosts have taught me.

REFERENCES

1 Philippe Ariès, *The Hour of Our Death*, trans. Helen Weaver (New York, 1982), p. 42.

2 Christianity is not, of course, the only religion to idealize death and worship martyrs. One need only consider the role of martyrdom in ancient and contemporary Islam to see similar tendencies in another tradition.

3 Ariès, *The Hour of Our Death*, p. 56.

4 Michael Ragon, *The Space of Death: A Study of Funerary Architecture, Decoration, and Urbanism*, trans. Alan Sheridan (Charlottesville, 1983), p. 20; Ariès, *The Hour of Our Death*, pp. 46–51.

5 Ariès, *The Hour of Our Death*, p. 56.

6 Ragon, *The Space of Death*, p. 51.

7 Ariès, *The Hour of Our Death*, p. 61.

8 When the French Revolution replaced the birth of Christ as the dividing point of history, the months were renamed with terms from nature. Prairial, which derives from 'prairie', ran from 20 May to 18 June. The precise date of this decree was 12 June 1804.

9 Ariès, *The Hour of Our Death*, p. 516. Cemeteries had to be at least 40 to 50 yards beyond city limits. I have drawn my account of this decree largely from Ariès' book.

10 *Ibid.*, p. 518. For further details, see Thomas Kselman, *Death and the Afterlife in Modern France* (Princeton, 1993), pp. 183-9.

11 Ragon, *The Space of Death*, p. 87.

12 For an insightful account and remarkable collection of photographs of Puritan gravestones, see Allan Ludwig, *Graven Images: New England Stonecarving and Its Symbols, 1650–1815* (Middletown, CT, 1966).

13 Ariès, *The Hour of Our Death*, pp. 517, 531.

14 As a result of the Rural Cemetery Movement, the term *churchyard* gradually gave way to *cemetery*.

15 Quoted in Ariès, *The Hour of Our Death*, p. 532.

16 Edgar Allan Poe, 'MS. Found in a Bottle', in *Poetry and Tales* (New York, 1984), p. 199.

17 Charles Baudelaire, 'The Painter of Modern Life', in *The Painter of Modern Life and Other Essays*, trans. Jonathan Mayne (New York, 1964), p. 13.

18 Don DeLillo, *The Body Artist* (New York, 2001), p. 69.

19 The contemporary artist Eve André Laramée coined the suggestive term *Netherzone*.

20 Ariès,*The Hour of Our Death*, p. 406.

21 Ray Kurzweil, *The Age of Spiritual Machines: When Computers Exceed Human Intelligence* (New York, 1999), pp. 128–9.

22 Hans Moravec, *Robot: Mere Machine to Transcendent Mind* (Oxford, 1999), pp. 169–70.

23 Maurice Blanchot, *The Unavowable Community*, trans. Pierre Joris (Barrytown, NY, 1988), p. 24.

24 Hugo Ott, *Martin Heidegger: A Political Life*, trans. Allan Blunden (New York, 1993), pp. 369–70.

25 Søren Kierkegaard, *Journals and Papers*, trans. Howard and Edna Hong (Bloomington, 1967), vol. I, p. 336.

26 Terry Pinkard, *Hegel: A Biography* (Cambridge, 2000), pp. 659–60. I have drawn the details of Hegel's death and funeral from this fine biography. Pinkard, however, does not think that Hegel died from cholera but from 'some kind of gastrointestinal disease'.

27 Quoted in *ibid.*, p. 660.

28 J. H. W. Stuckenberg, *The Life of Immanuel Kant* (New York, 1986), p. 447.

29 Others who were cremated include T. S. Eliot, Sigmund Freud, Paul Klee, Gottfried Wilhelm Leibniz, Charles Sanders Peirce and Virginia Woolf.

30 Hermione Lee, *Virginia Woolf* (London, 1996), pp. 765–6.

31 Samuel Sacy, quoted in Jack Rochford Vrooman, *René Descartes: A Biography* (Paris, 1970), p. 252.

32 Stephen Gaukroger, *Descartes: An Intellectual Biography* (New York, 1955), pp. 416–17. In assembling the details of Descartes' multiple burials, I have also drawn on Elizabeth Haldane, *Descartes: His Life and Times* (New York, 1905), pp. 348–53, and Vrooman, *René Descartes*, pp. 242–55.

33 Gaukroger, *Descartes*, p. 417.

34 Henry David Thoreau, *Walden* (Princeton, 1988), p. 66.

35 Emily Dickinson, *Selected Poems and Letters of Emily Dickinson*, ed. Robert Linscott: New York, 1959), p. 151.

36 Quoted in Cynthia Griffin Wolff, *Emily Dickinson* (New York, 1986), p. 535.

37 *Ibid.*, p. 535.

38 Edgar Allan Poe, 'The Premature Burial', in Poe, *Poetry and Tales*, p. 666.

39 Quoted in David Sinclair, *Edgar Allan Poe* (Totowa, NJ, 1977), p. 246.

40 *Ibid.*, p. 252.

41 Quoted in *ibid.*, p. 255.

42 Several years later, Neilson Poe arranged to have a marker placed on the grave, but the stone was broken when a freight train jumped the track in the yard where the marble was being carved. The grave remained virtually unmarked until 1875, when Poe's body was moved to a different part of the cemetery and a memorial erected. It took almost ten years for local educators and teachers to raise the money for the marker. Most dignitaries declined the invitation to attend the ceremony dedicating the memorial. Walt Whitman was the only poet or writer who was present (Julian Symons, *The Tell-Tale Heart: The Life and Works of Edgar Allan Poe* [New York, 1981], pp. 153–4, 164–6).

43 Leonard Howard, *Herman Melville* (Berkeley, 1951), pp. 283–4.

44 Herman Melville, *Moby-Dick or, The Whale* (Berkeley, 1979), pp. 197–8.

45 Wallace Stevens, 'The Snow Man', in *The Collected Poems of Wallace Stevens* (New York, 1981), p. 10.

46 Maurice Blanchot, *The Instant of My Death*; Jacques Derrida, *Demeure: Fiction and Testimony*, trans. Elizabeth Rottenberg (Stanford, 1998), p. 3.

47 Maurice Blanchot, *Awaiting Oblivion*, trans. John Gregg (Lincoln, NB, 1997), pp. 46–7.

48 Roland Barthes, *Camera Lucida: Reflections on Photography*, trans. Richard Howard (New York, 1981), pp. 15, 13–14.

49 Maurice Blanchot, *The Work of Fire*, trans. Charlotte Mandell (Stanford, 1995), p. 329.

50 Maurice Blanchot, 'The Two Versions of the Imaginary', in *The Space of Literature*, trans. Ann Smock (Lincoln, NB, 1982), pp. 255–6.

51 G. W. F. Hegel, *Phenomenology of Spirit*, trans. A. V. Miller (New York, 1977), p. 19.

52 Herman Melville, *Pierre or The Ambiguities*, in *Herman Melville* (New York, 1984), p. 3.

Francis Bacon, 1561–1626, St Michael's Church, St Albans, England

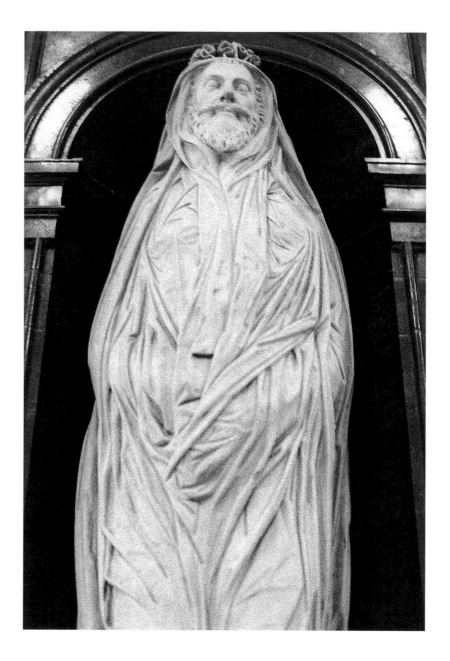

John Donne, 1573–1631, St Paul's Cathedral, London, England

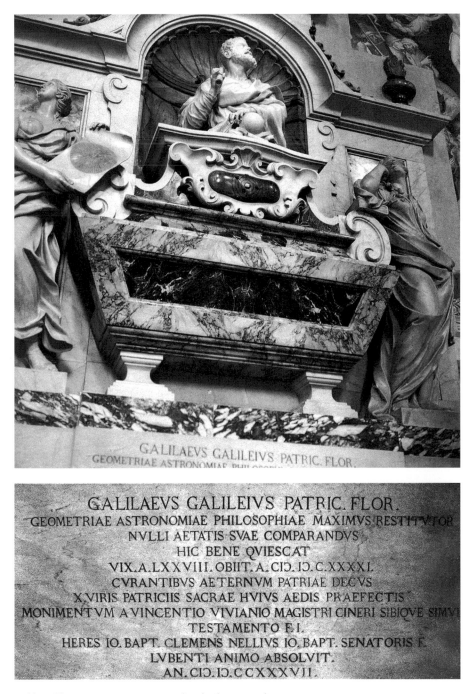

Galilei Galileo, 1564–1642, Santa Croce Church, Florence, Italy

René Descartes, 1596–1650, St-Germain-des-Prés, Paris, France

EPITAPHE

DE BLAISE PASCAL.

PRO COLUMNA SUPERIORI,
SUB TUMULO MARMOREO,

JACET BLASIUS PASCAL CLAROMONTA-
NUS STEPHANI PASCAL IN SUPREMA APUD
ARVERNOS SUBSIDIOROM CURIA PRÆSI-
DIS FILIUS, POST ALIQUOT ANNOS IN SEVE
RIORI SECESSU ET DIVINÆ LEGIS MEDI-
TATIONE TRANSACTOS, FÆLICITER ET
RELIGIOSE IN PACE CHRISTI VITA FUNC-
TUS, ANNO 1662. ÆTATIS 39.° DIE 19.ᴬ
AUGUSTI. OPTASSET ILLE QUIDEM
PRÆ PAUPERTATIS ET HUMILITATIS
STUDIO ETIAM HIS SEPULCHRI HONO-
RIBUS CARERE, MORTUUSQUE ETIAM-
NUM LATERE QUI VIVUS SEMPER LATERE
VOLUERAT VERUM EJUS IN HAC PARTE
VOTIS CUM CEDERE NON POSSET
FLORINUS PERIER IN EADEM SUBSIDIO-
RUM CURIA CONSILIARIUS, GILBERTÆ
PASCAL BLASIJ PASCAL SORORIS CONJUX
AMANTISSIMUS, HANC TABULAM POSUIT
QUA ET SUAM IN ILLUM PIETATEM
SIGNIFICARET, ET CHRISTIANOS AD
CHRISTIANA PRECUM OFFICIA SIBI AC
DEFUNCTO PROFUTURA COHORTARETUR.

Blaise Pascal, 1623–1662, St Etienne-du-Mont, Paris, France

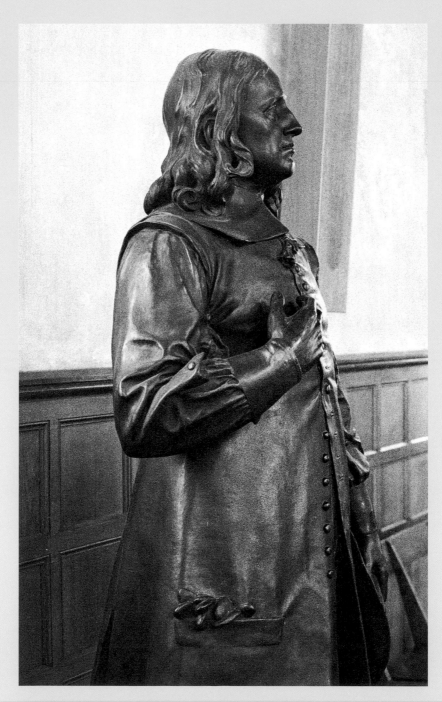

John Milton, 1608–1674, St Giles Cripplegate Church, London, England

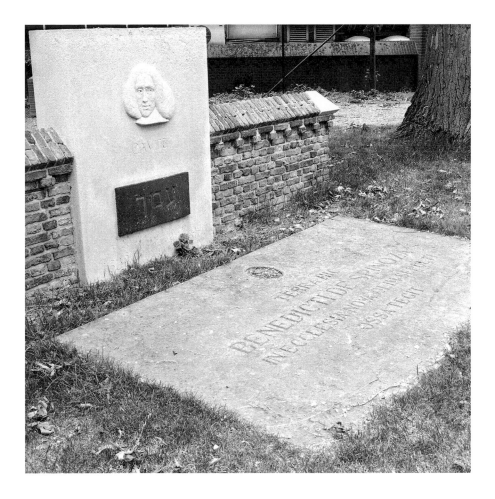

Benedict Baruch Spinoza, 1632–1677, New Church, The Hague, Holland

Thomas Hobbes, 1588–1679, Ault Hucknall, England

Condita hic sunt Ofsa
THOMÆ HOBBES
MALMESBURIENSIS,
Qui per multos annos servivit
Duobus DEVONIÆ comitibus
Patri et Filio.

Vir Probus, et Famâ Eruditioni
Domi Forisque bene cognitus,

Obiit Ann. Domini 1679.
Mensis Decembris die 4.
Ætatis suæ 91

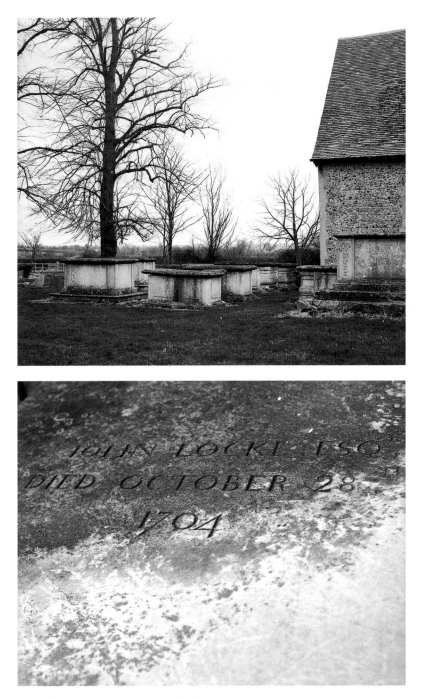

John Locke, 1632–1704, High Laver, England

Gottfried Wilhelm Leibniz, 1646–1716, Hanover, Germany

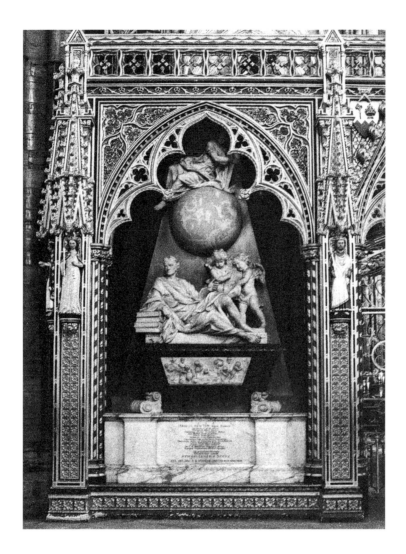

Isaac Newton, 1624–1727, Westminster Abbey, London, England

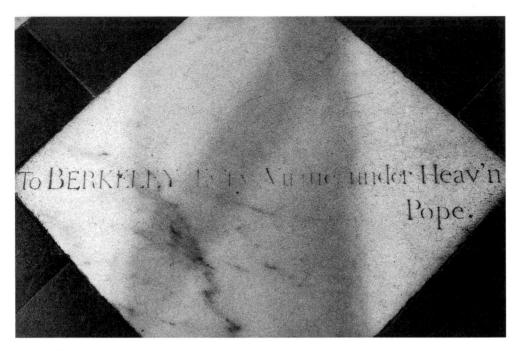

George Berkeley, 1685–1753, Christchurch, Oxford, England

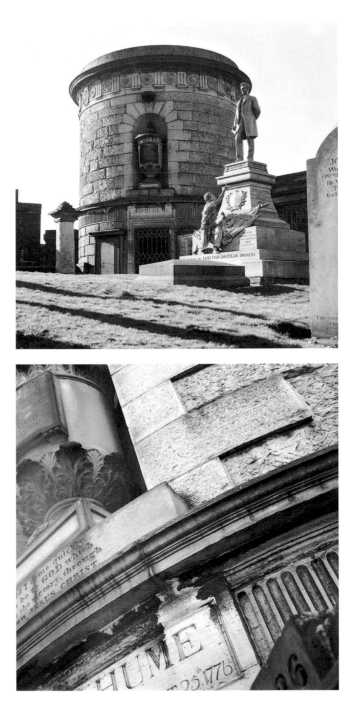

David Hume, 1711–1776, Calton Old Burial Ground, Edinburgh, Scotland

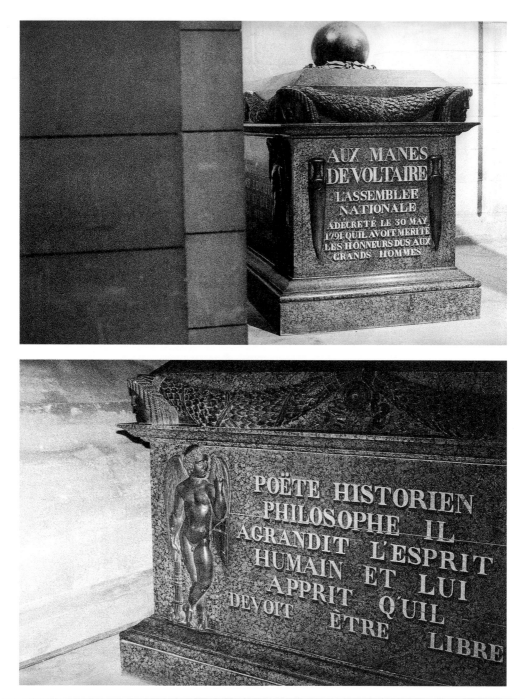

Voltaire (François-Marie Arouet), 1694–1778, The Pantheon, Paris, France

Jean-Jacques Rousseau, 1712–1778, The Pantheon, Paris, France

Denis Diderot, 1713–1784, St-Roch, Paris, France

Opposite: *Gotthold Ephraim Lessing, 1729–1781*, Braunschweig, Germany

Benjamin Franklin, 1706–1790, Christ Church Burial Grounds, Philadelphia, Pennsylvania, USA

Adam Smith, 1723–1790, Canongate, Edinburgh, Scotland

The inscription on the memorial reads:

Edmund Burke, patriot, orator, statesman, lived at Butlers Court, formerly Gregories, in this parish from 1769 to 1797. This memorial, placed here by public subscription, records the undying honour in which his name is held. July 9, 1898

Edmund Burke, 1729–1797, Beaconsfield, England

Opposite: *Wolfgang Amadeus Mozart, 1756–1791*, Zentralfriedhof, Vienna, Austria

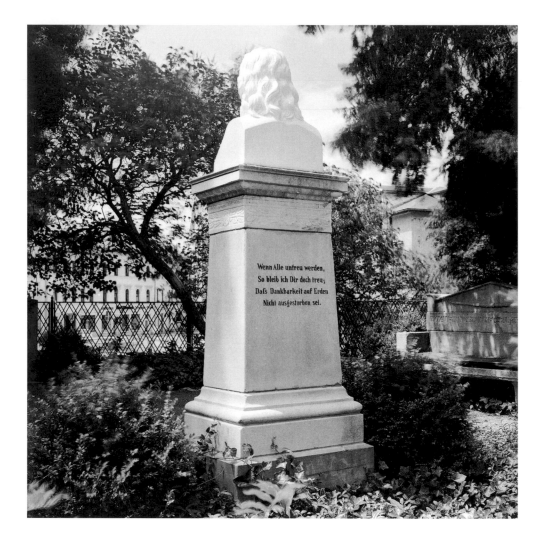

Wenn Alle untreu werden,
So bleib ich Dir doch treu;
Daſs Dankbarkeit auf Erden
Nicht ausgestorben sei.

Novalis, 1772–1801, Weissenfels, Germany

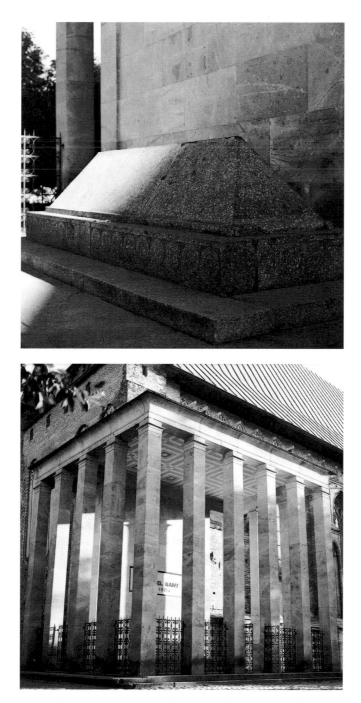

Immanuel Kant, 1724–1804, Domkirche zu Königsberg, Kaliningrad, Russia

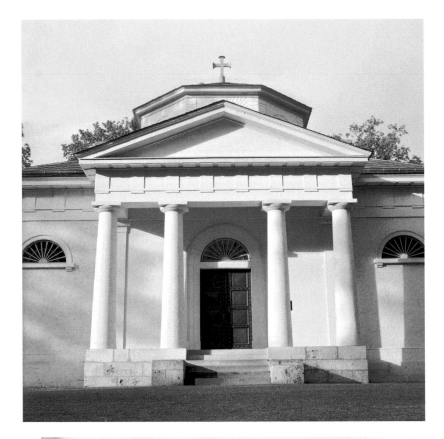

Friedrich Schiller, 1759–1805, Historischer Friedhof, Wiemar, Germany

Johann Wolfgang von Goethe, 1749–1832, Historischer Friedhof, Wiemar, Germany

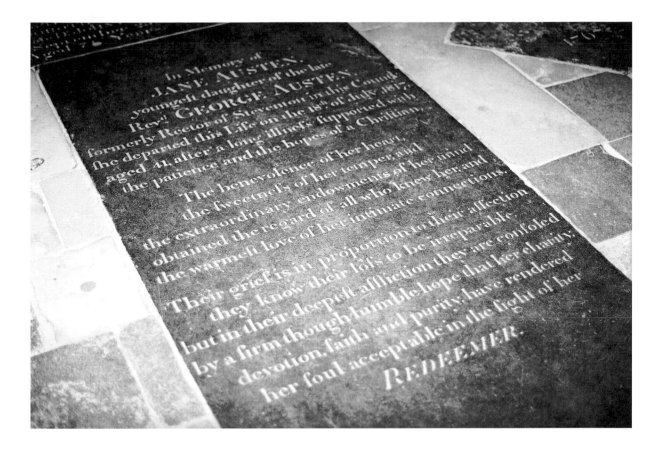

In Memory of
JANE AUSTEN,
youngest daughter of the late
Rev.d GEORGE AUSTEN,
formerly Rector of Steventon in this County.
she departed this Life on the 18.th of July 1817,
aged 41, after a long illness supported with
the patience and the hopes of a Christian.

The benevolence of her heart,
the sweetness of her temper, and
the extraordinary endowments of her mind
obtained the regard of all who knew her and
the warmest love of her intimate connections.

Their grief is in proportion to their affection
they know their loss to be irreparable,
but in their deepest affliction they are consoled
by a firm though humble hope that her charity,
devotion, faith and purity have rendered
her soul acceptable in the sight of her
REDEEMER.

Jane Austen, 1775–1817, Winchester Cathedral, England

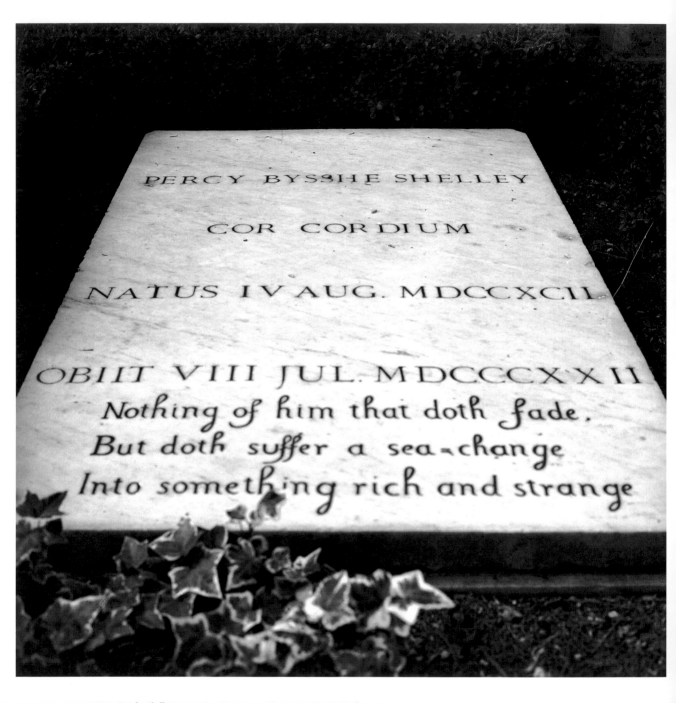

Percy Bysshe Shelley, 1792–1822, Protestant Cemetery, Rome, Italy

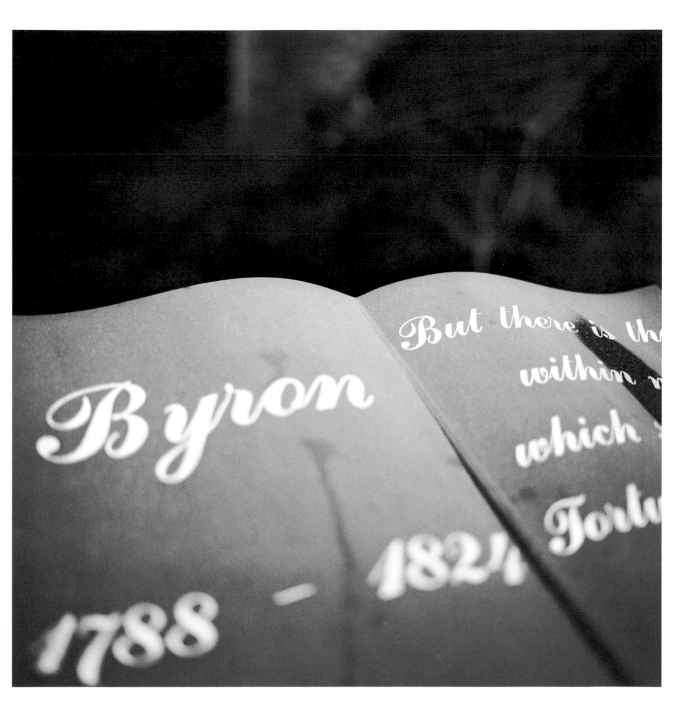

Lord Byron (George Gordon), 1788–1824, Hucknall Torkard Parish Church, St Mary Magdalene, Hucknall, England

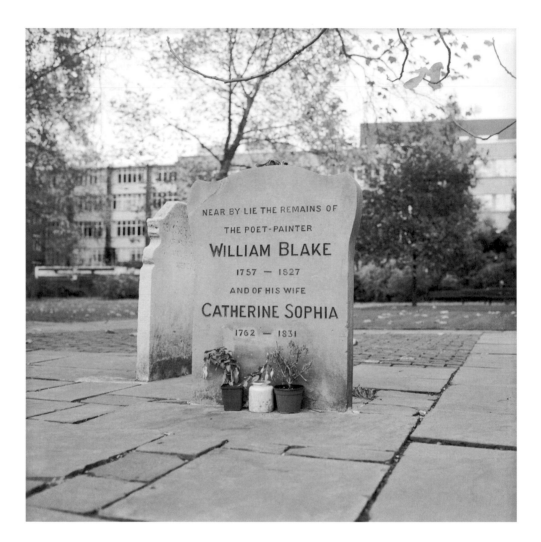

William Blake, 1757–1827, Bunhill Fields, London, England

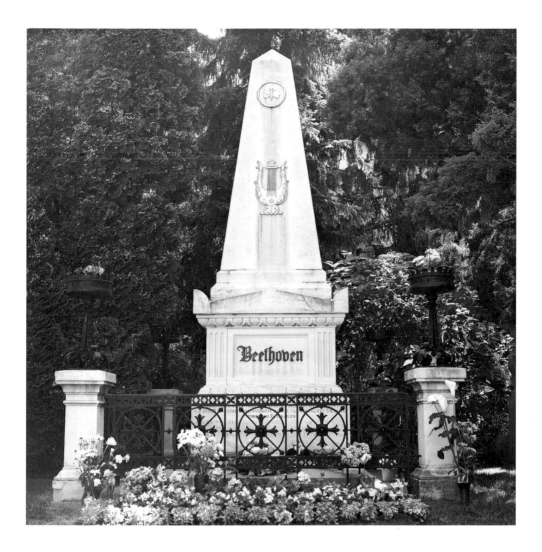

Ludwig van Beethoven, 1770–1827, Zentralfriedhof, Vienna, Austria

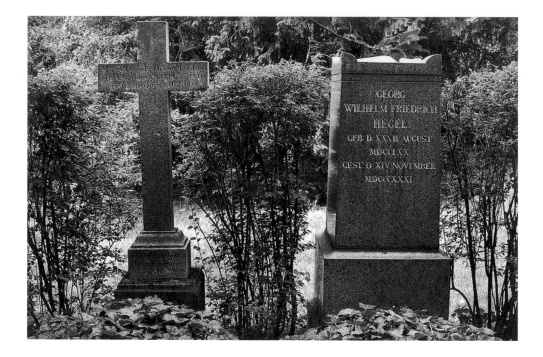

G. W. F. Hegel, 1770–1831, Dorotheenstädtische Friedhof und Friedrich-Werschen Gemeinder, Berlin, Germany

Jeremy Bentham, 1748–1832, University College London, England

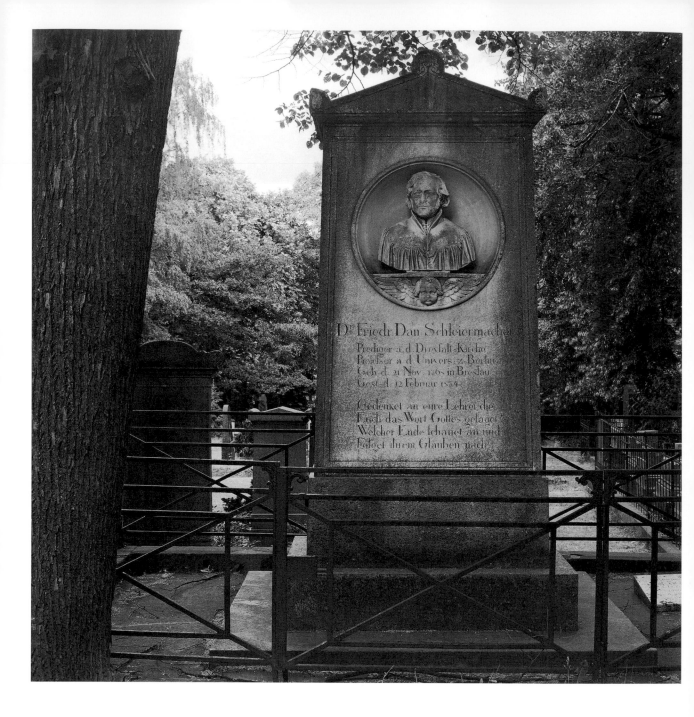

Friedrich Schleiermacher, 1768–1834, Trinity Church Cemetery, Berlin, Germany

Opposite: *Samuel Taylor Coleridge, 1772–1834*, St Michael's Church, London, England

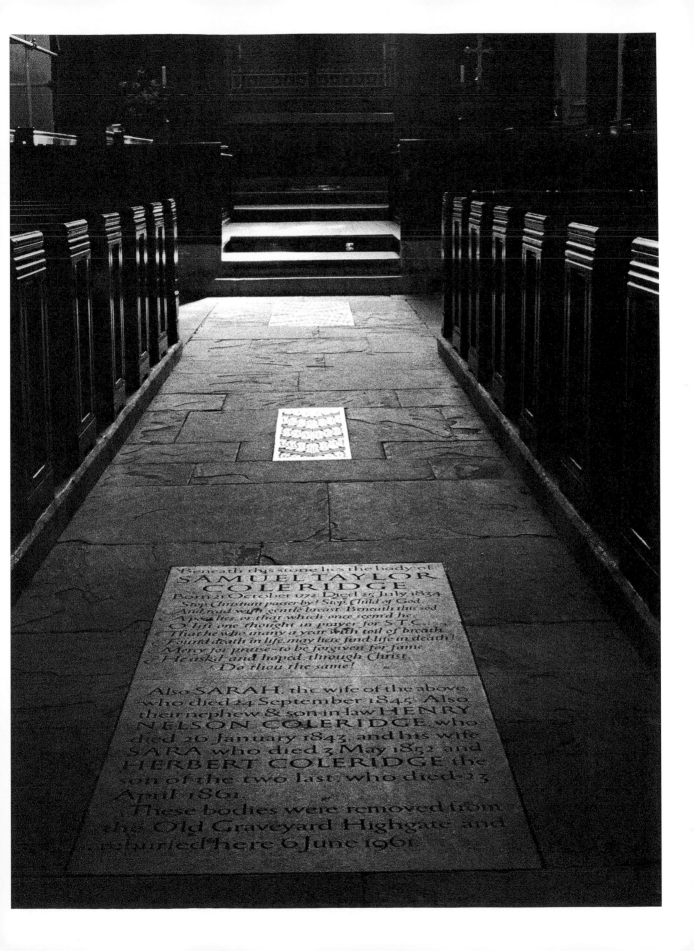

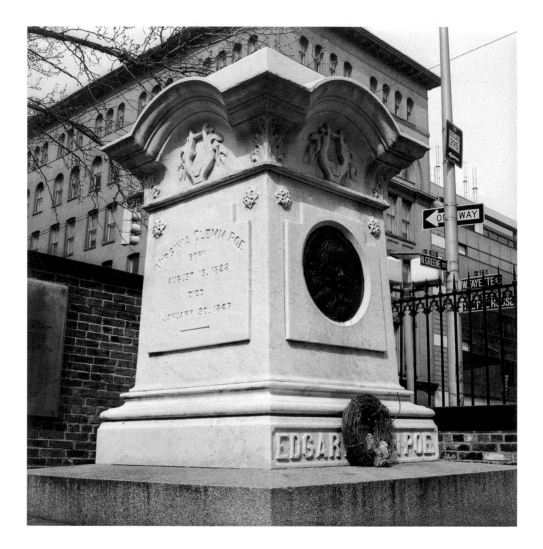

Edgar Allan Poe, 1809–1849, Westminster Presbyterian Churchyard, Baltimore, Maryland, USA

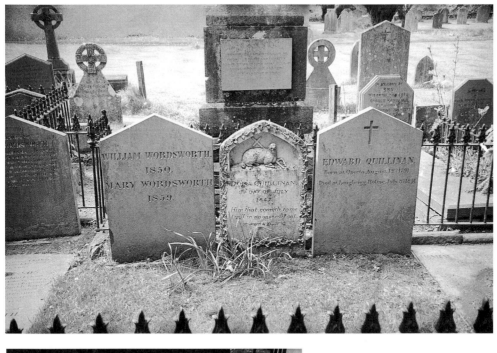

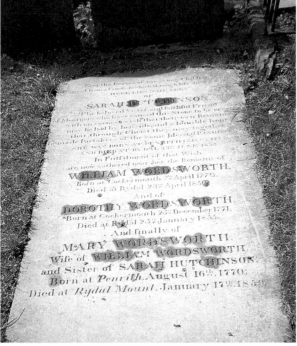

William Wordsworth, 1770–1850,
St Oswald's Churchyard,
Grasmere, England

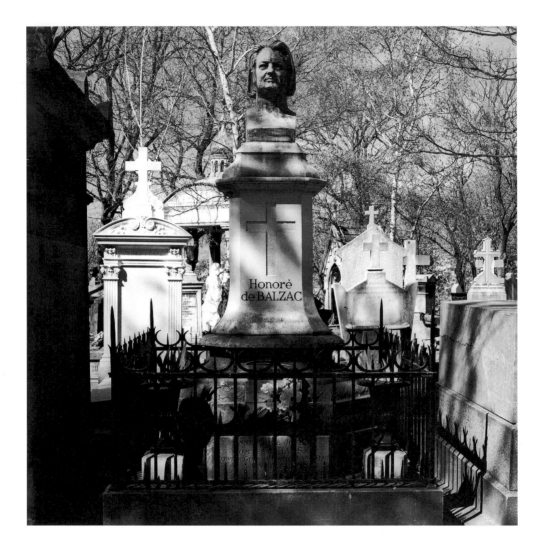

Honoré de Balzac, 1799–1850, Le Cimetière du Père-Lachaise, Paris, France

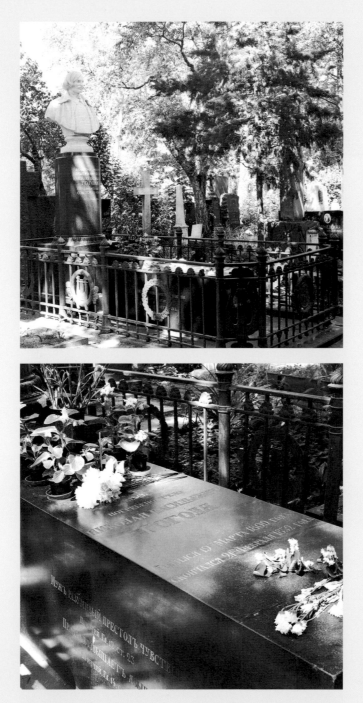

Nikolai Vasilyevich Gogol, 1809–1852, Novodevichy Cemetery, Moscow, Russia

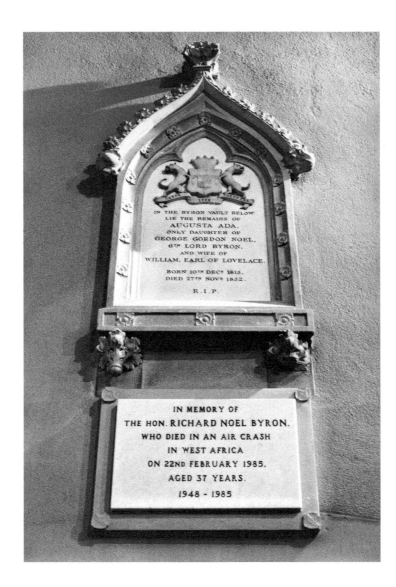

IN THE BYRON VAULT BELOW
LIE THE REMAINS OF
AUGUSTA ADA,
ONLY DAUGHTER OF
GEORGE GORDON NOEL,
6TH LORD BYRON,
AND WIFE OF
WILLIAM, EARL OF LOVELACE.

BORN 10TH DECR 1815.
DIED 27TH NOVR 1852.

R.I.P.

IN MEMORY OF
THE HON. RICHARD NOEL BYRON.
WHO DIED IN AN AIR CRASH
IN WEST AFRICA
ON 22ND FEBRUARY 1985.
AGED 37 YEARS.
1948 - 1985

Ada Lovelace (Augusta King), 1815–1852, Hucknall Torkard Parish Church,
St Mary Magdalene, Hucknall, England

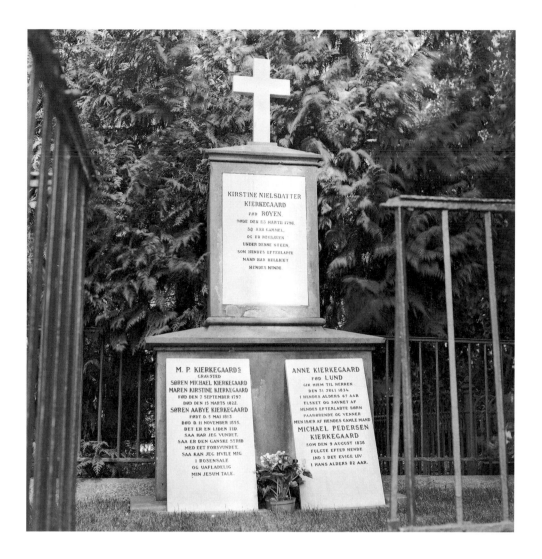

Søren Kierkegaard, 1813–1855, Assistents Churchyard, Copenhagen, Denmark

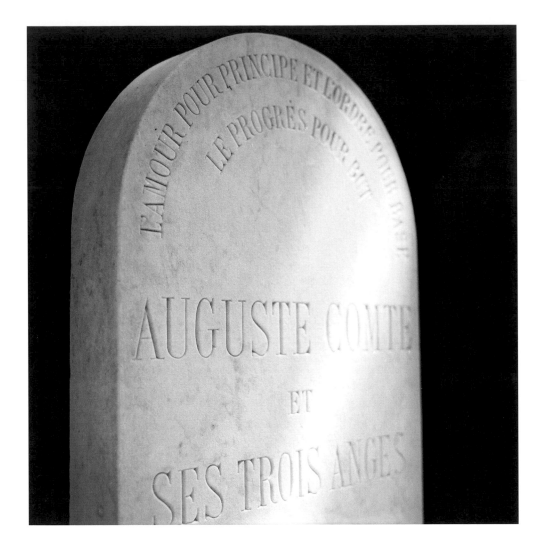

Auguste Comte, 1798–1857, Le Cimetière du Père-Lachaise, Paris, France

Arthur Schopenhauer, 1788–1860, Frankfurter Friedhof, Frankfurt, Germany

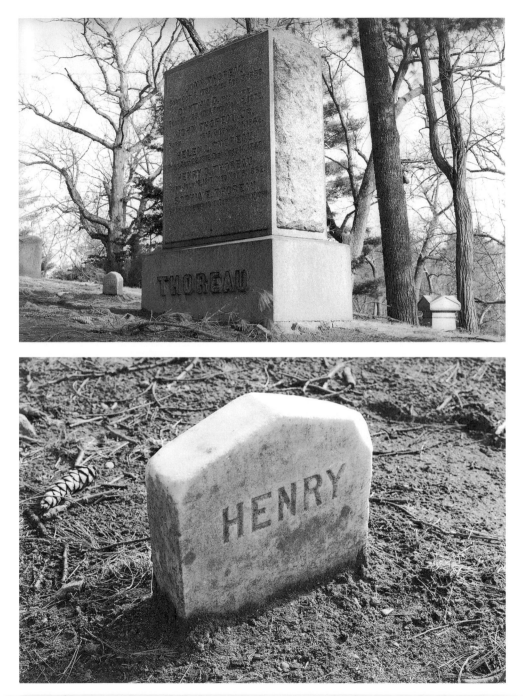

Henry David Thoreau, 1817–1862, Sleepy Hollow Cemetery, Concord, Massachusetts, USA

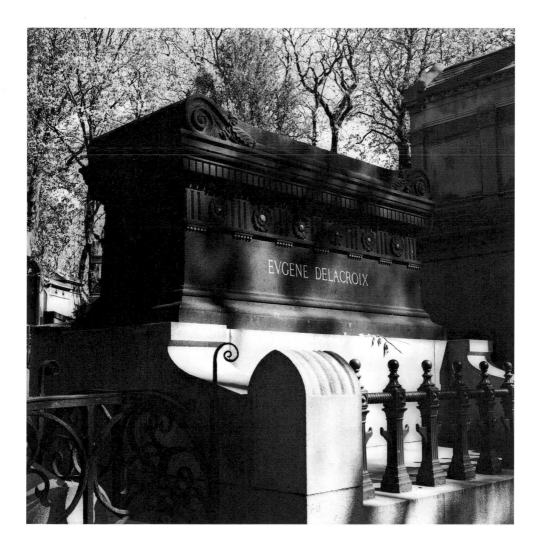

Eugène Delacroix, 1799–1863, Le Cimetière du Père-Lachaise, Paris, France

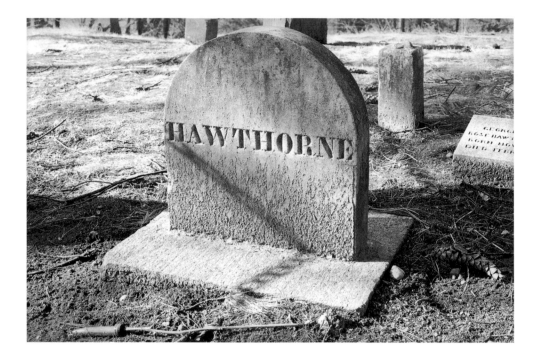

Nathaniel Hawthorne, 1804–1864, Sleepy Hollow Cemetery, Concord, Massachusetts, USA

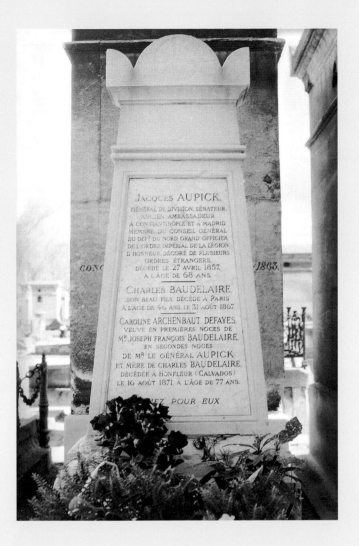

Charles Baudelaire, 1821–1867, Le Cimetière du Montparnasse, Paris, France

John Stuart Mill, 1806–1873, Cimetière St Veran, Avignon, France

Gustave Courbet, 1819–1877, Ornans, France

George Eliot (Marian Evans), 1819–1880, Highgate Cemetery, London, England

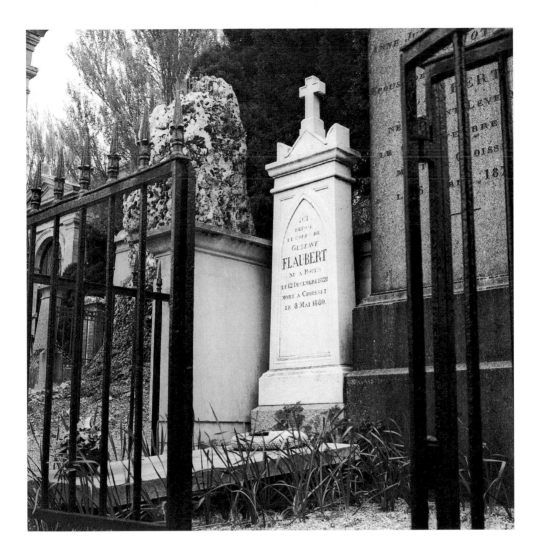

Gustave Flaubert, 1821–1880, Cimetière Monumental, Rouen, France

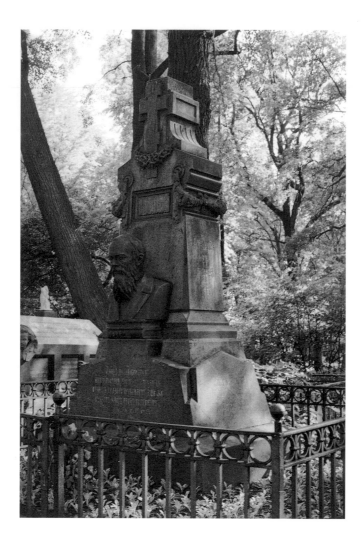

Fyodor Dostoyevsky, 1821–1881, Tikhvin Cemetery, St Petersburg, Russia

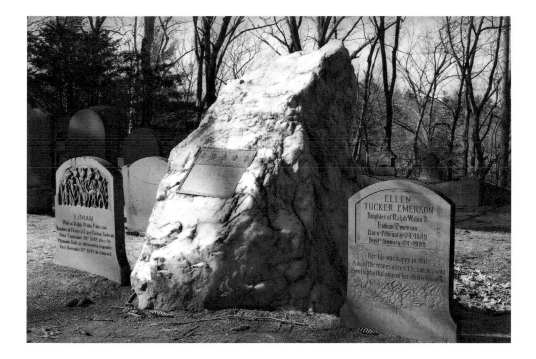

Ralph Waldo Emerson, 1803–1882, Sleepy Hollow Cemetery, Concord, Massachusetts, USA

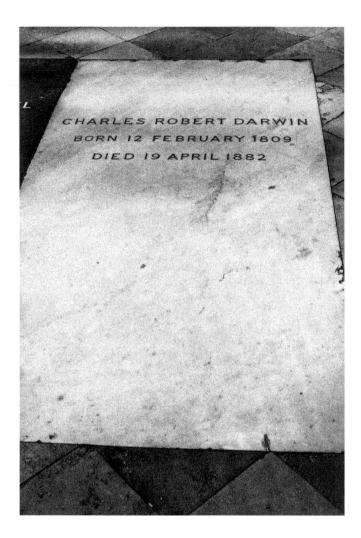

Charles Darwin, 1809–1882, Westminster Abbey, London, England

Opposite: *Richard Wagner, 1813–1883,* Wagner House, Bayreuth, Germany

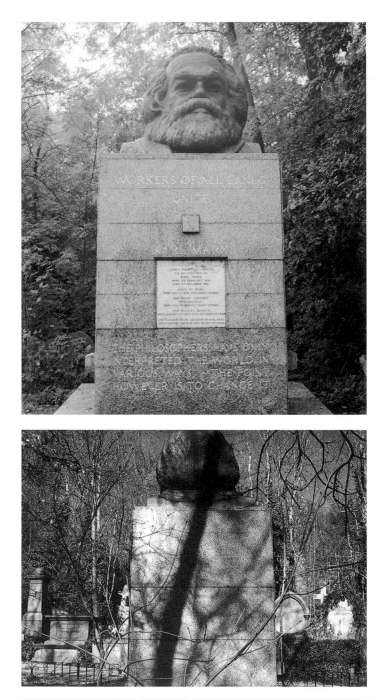

Karl Marx, 1818–1883, Highgate Cemetery, London, England

Edouard Manet, 1832–1883, Le Cimetière de Passy, Paris, France

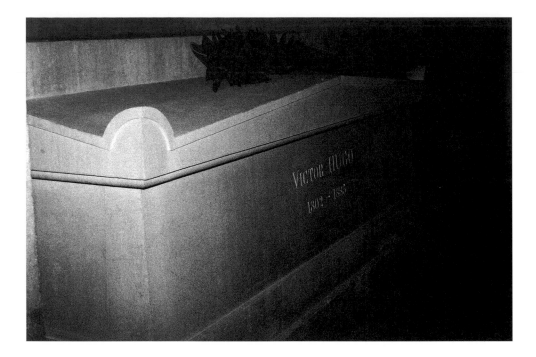

Victor Hugo, 1802–1885, The Pantheon, Paris, France

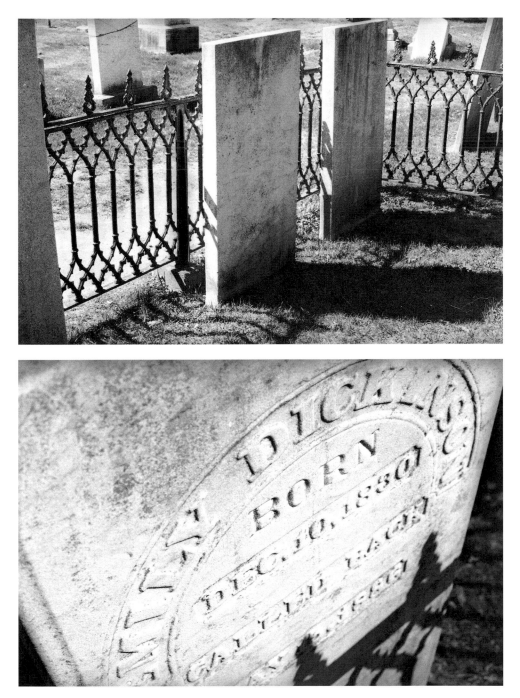

Emily Dickinson, 1830–1886, West Cemetery, Amherst, Massachusetts, USA

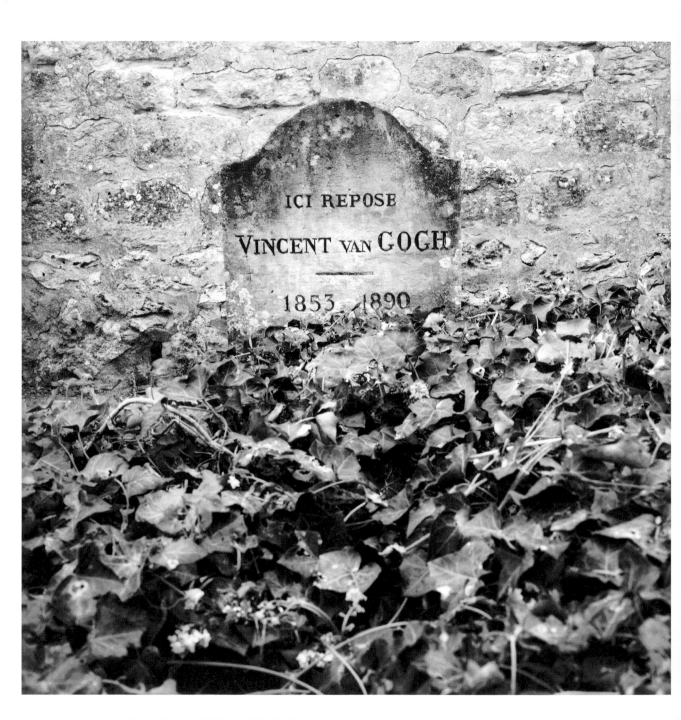

Vincent van Gogh, 1853–1890, Auvers-sur-Oise, France

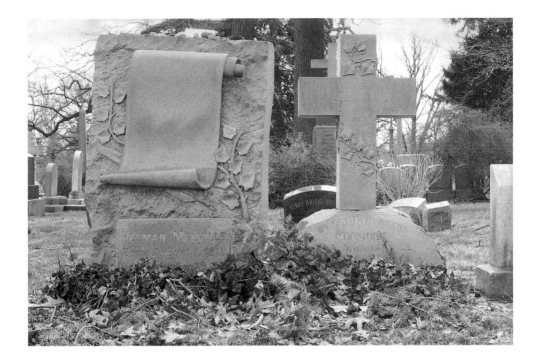

Herman Melville, 1819–1891, Woodlawn Cemetery, Bronx, New York, USA

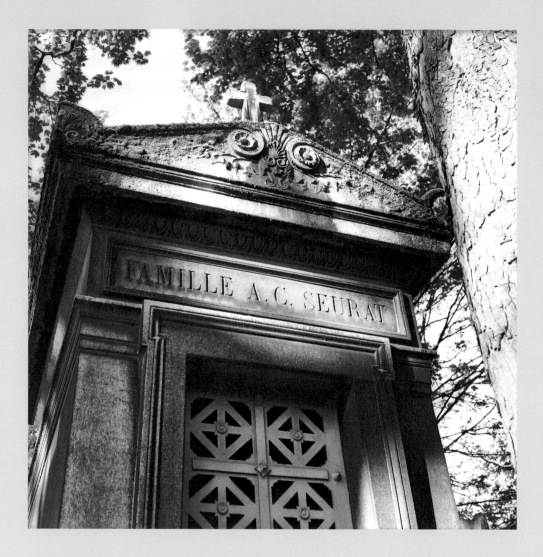

Georges Seurat, 1859–1891, Le Cimetière du Père-Lachaise, Paris, France

Opposite: *Walt Whitman, 1819–1892*, Harleigh Cemetery, Camden, New Jersey, USA

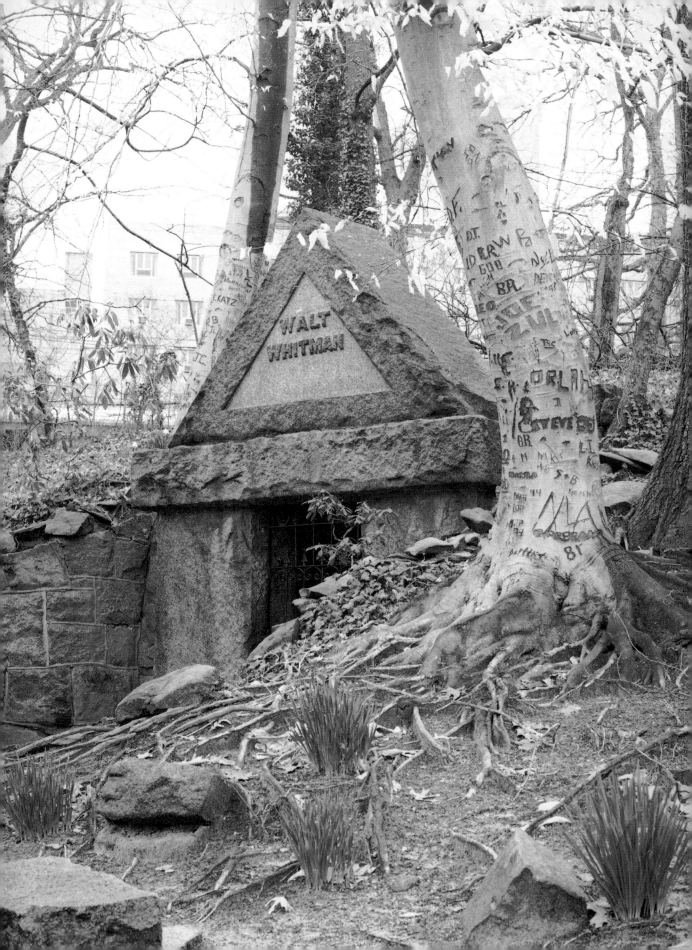

Friedrich Engels, 1820-1895, Eastbourne, England

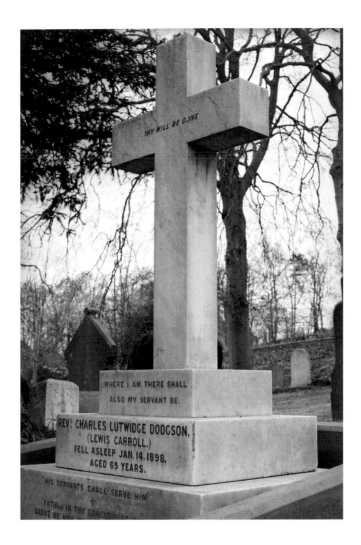

Lewis Carroll (Charles Lutwidge Dodgson), 1832–1898, Guildford, England

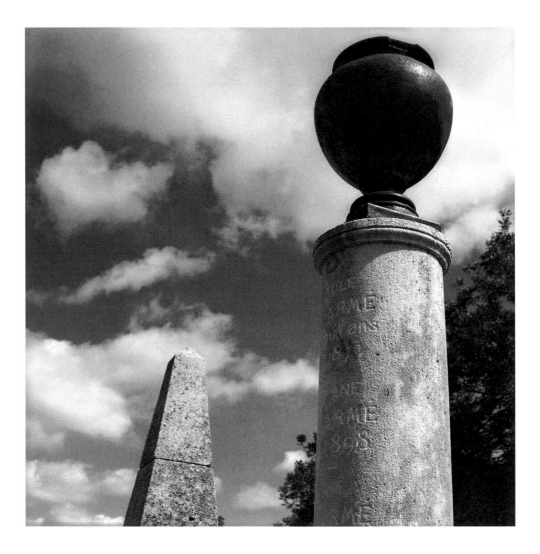

Stephane Mallarmé, 1842–1898, Samoreau, France

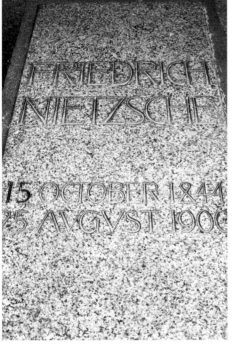

Friedrich Nietzsche, 1844–1900,
Röcken Church, Germany

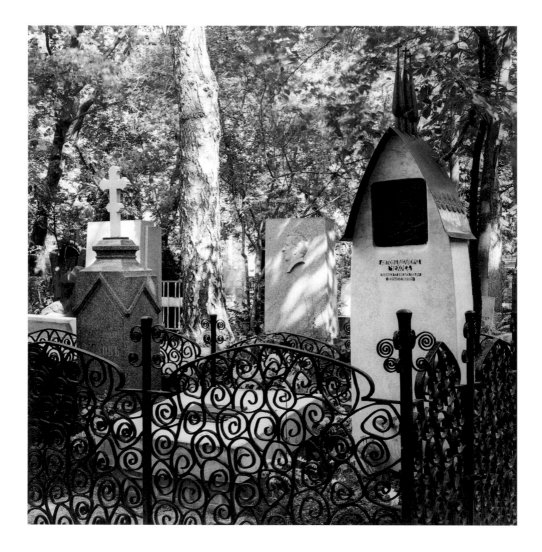

Anton Chekhov, 1860–1904, Novodevichy Cemetery, Moscow, Russia

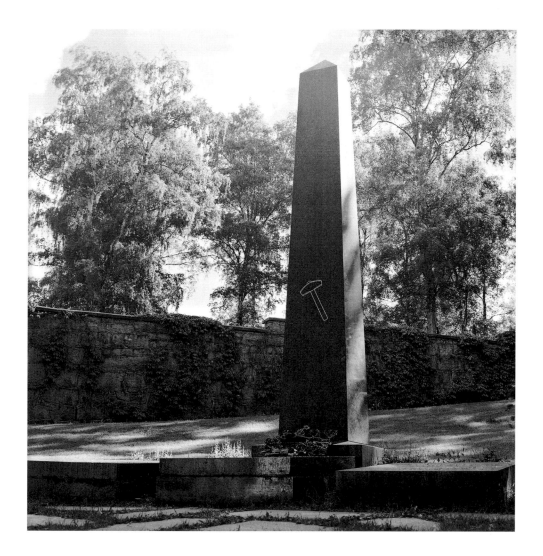

Henrik Ibsen 1828–1906, Vår Frelsers Gravlund, Oslo, Norway

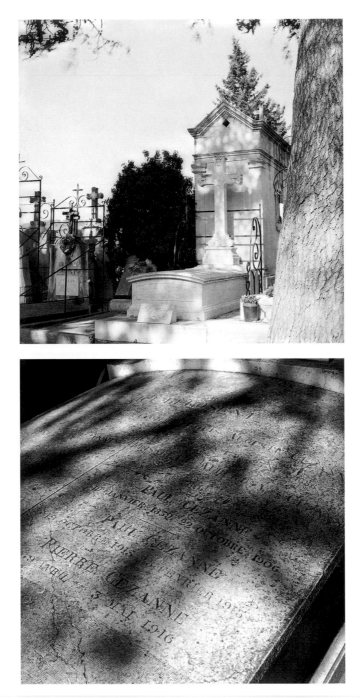

Paul Cézanne, 1839–1906, Cimetière St Pierre, Aix-en-Provence, France

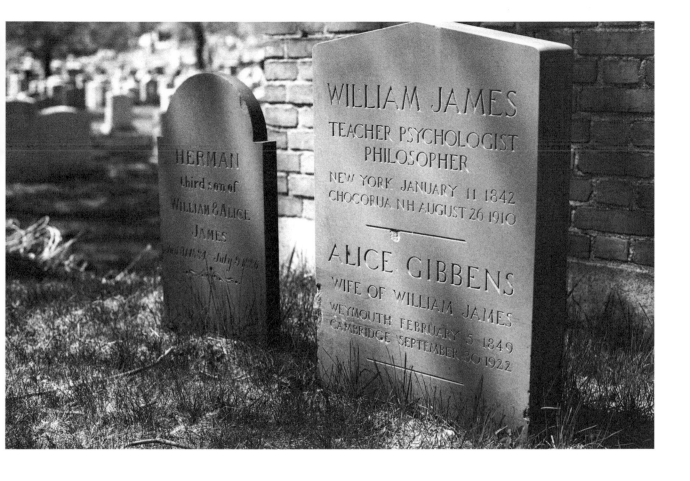

William James, 1842–1910, Cambridge Cemetery, Massachusetts, USA

Charles Sanders Peirce, 1839–1914, Milford Cemetery, Pennsylvania, USA

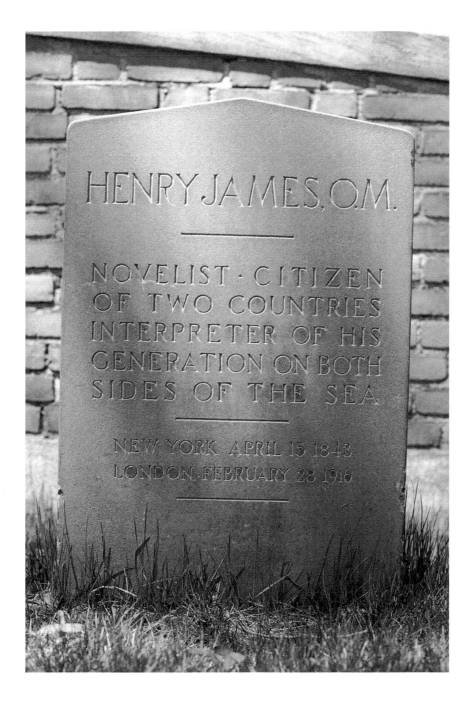

Henry James, 1843–1916, Cambridge Cemetery, Massachusetts, USA

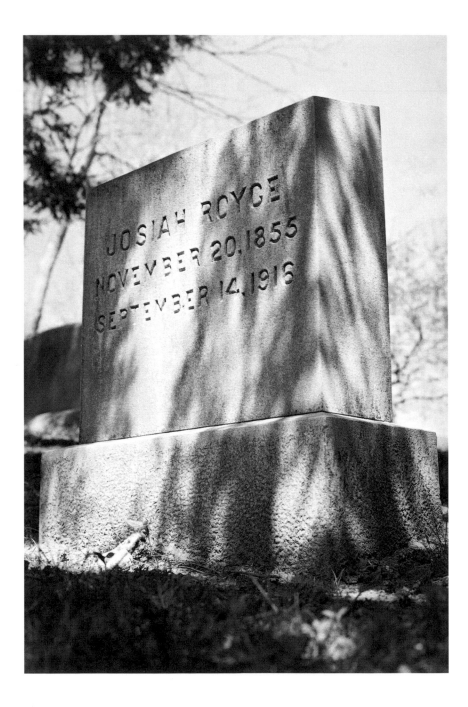

Josiah Royce, 1855–1916, Mount Auburn Cemetery, Cambridge, Massachusetts, USA

Edgar Degas, 1834–1917, Le Cimetière de Montmartre, Paris, France

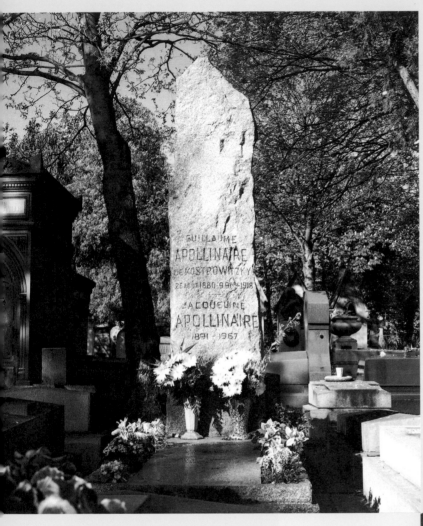

Guillaume Apollinaire, 1880–1918,
Le Cimetière du Père-Lachaise,
Paris, France

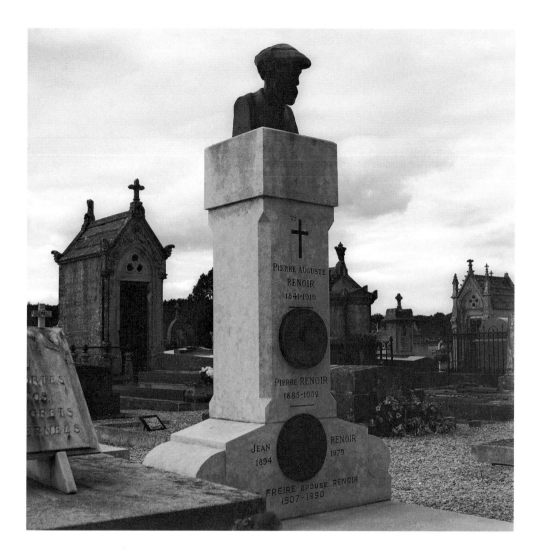

Auguste Renoir, 1841–1919, Essoyes, France

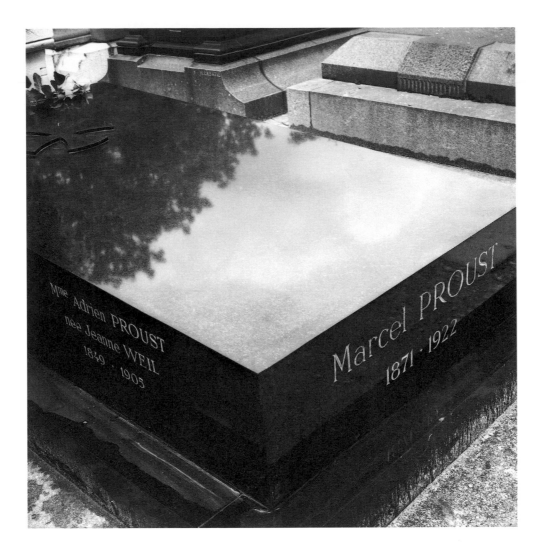

Marcel Proust, 1871–1922, Le Cimetière du Père-Lachaise, Paris, France

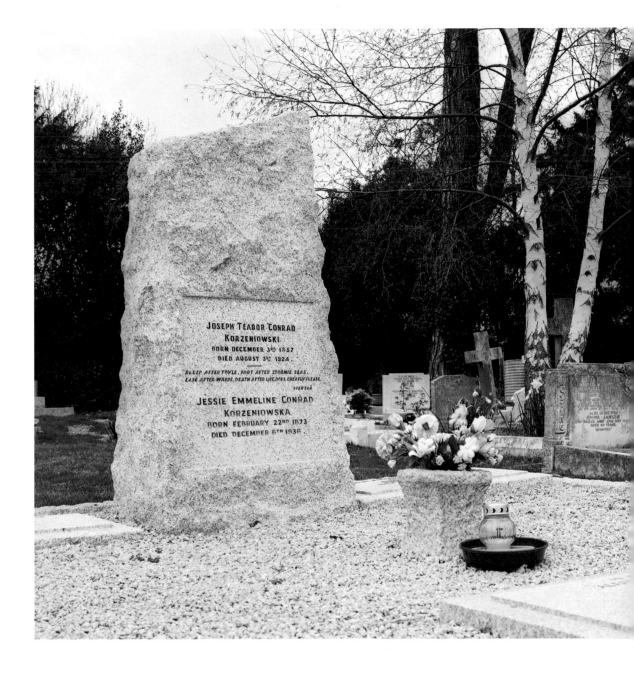

Joseph Conrad, 1857–1924, Canterbury, England

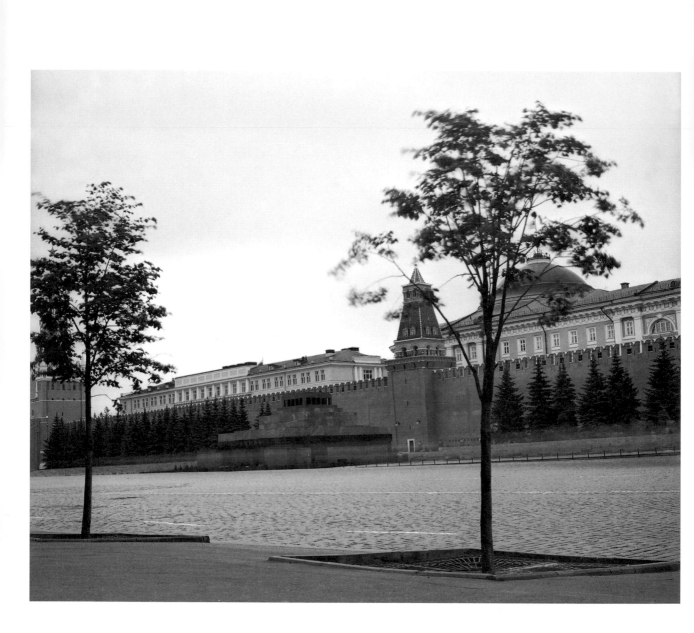

V. I. Lenin, 1870–1924, Red Square, Moscow, Russia

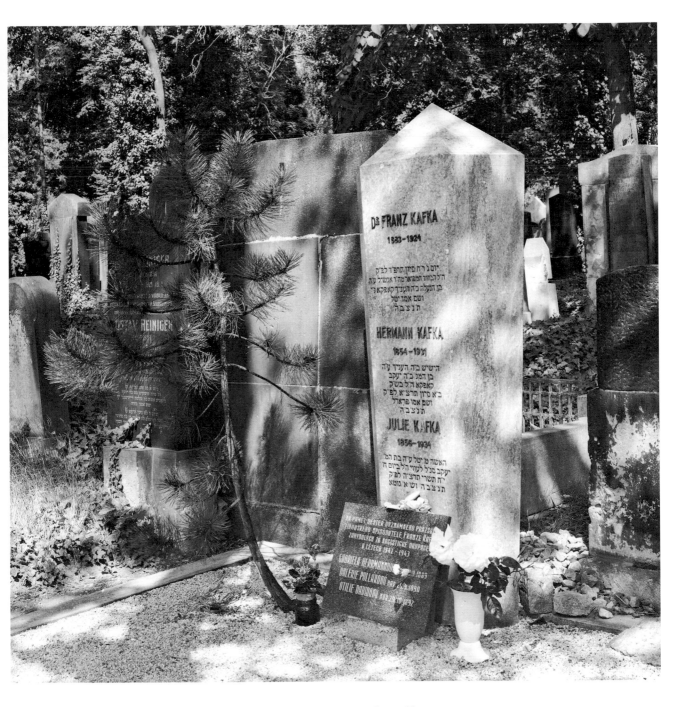

Franz Kafka, 1883–1924, New Jewish Cemetery, Prague, Czech Republic

Claude Monet, 1840–1926, Giverny Church Cemetery, France

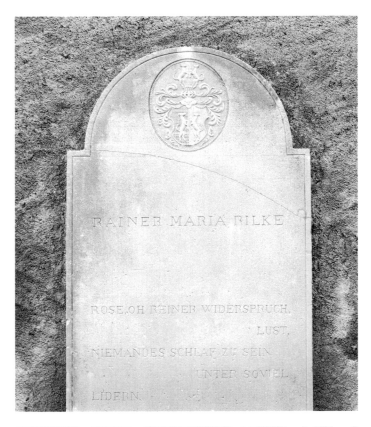

Rainer Maria Rilke, 1875–1926, Raron Churchyard, Switzerland

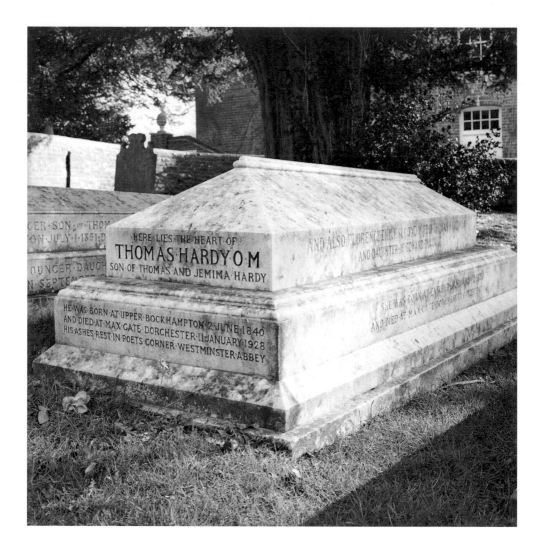

Thomas Hardy, 1840–1928, Stinsford, Dorset, England

Vladimir Mayakovsky, 1893–1930, Novodevichy Cemetery, Moscow, Russia

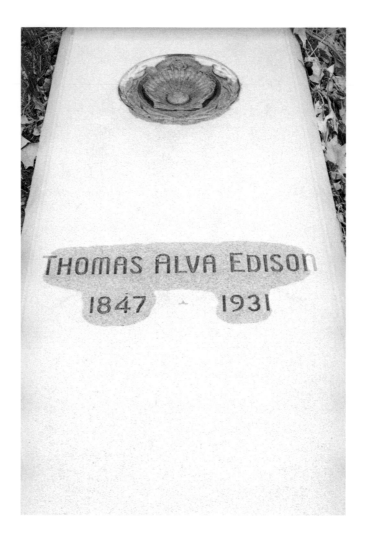

THOMAS ALVA EDISON
1847 ~ 1931

Thomas Edison, 1847–1931, Edison National Historic Site, West Orange, New Jersey, USA

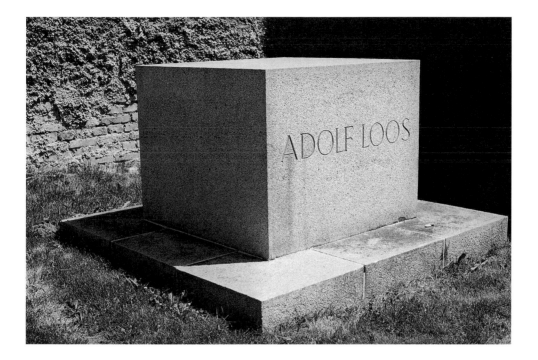

Adolf Loos, 1870–1933, Zentralfreidhof, Vienna, Austria

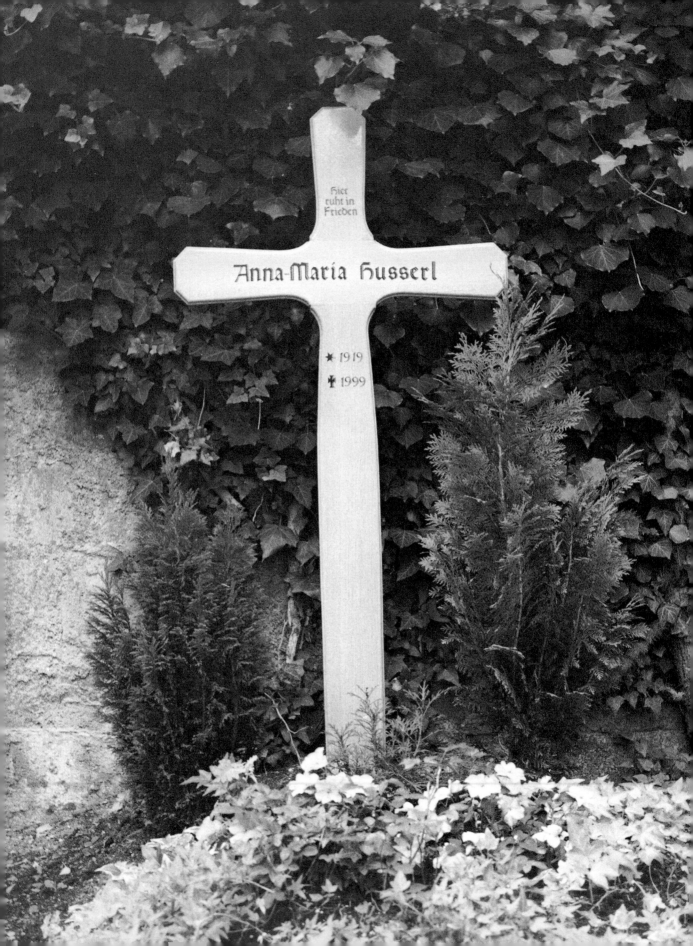

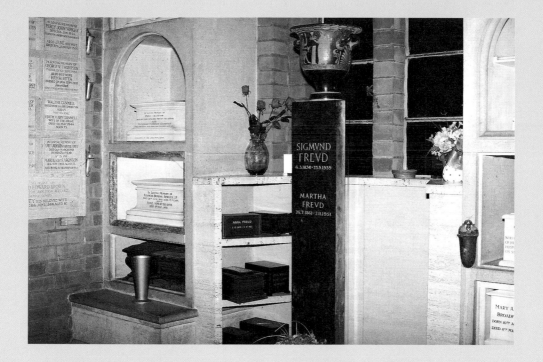

Sigmund Freud, 1856–1939, Golders Green Crematorium, London, England

Opposite: *Edmund Husserl, 1859–1938*, Göntherstal bei Freiburg, Germany

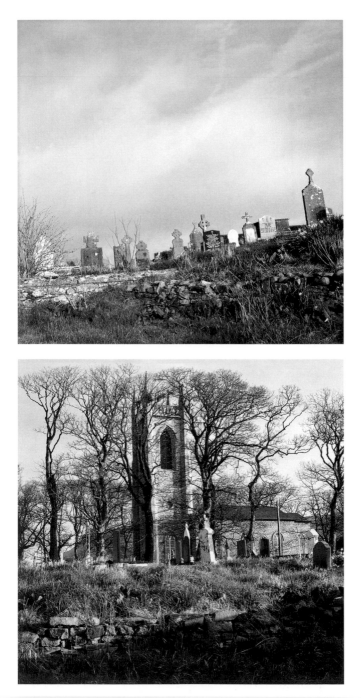

W. B. Yeats, 1865–1939, Drumcliff, Ireland

Paul Klee, 1879–1940, Schlosshalden Cemetery, Bern, Switzerland

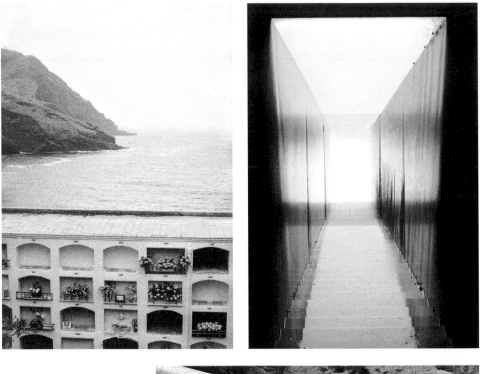

Walter Benjamin, 1892–1940,
Port-Bou, Spain

134

Henri Bergson, 1859–1941, Garches, France

Virginia Woolf, 1882–1941, Rodmell, East Sussex, England

Opposite: *James Joyce, 1882–1941*, Fluntern Cemetery, Zurich, Switzerland

Edvard Munch, 1863–1944, Vår Frelsers Gravlund, Oslo, Norway

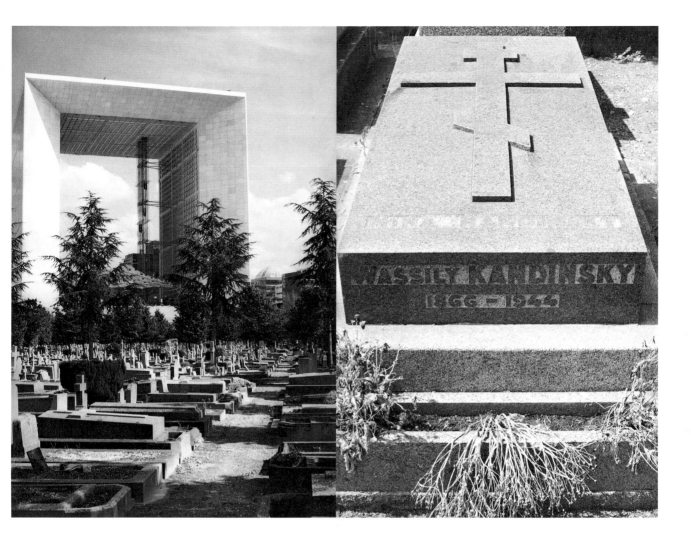

Wassily Kandinsky, 1866–1944, Neuilly-sur-Seine, France

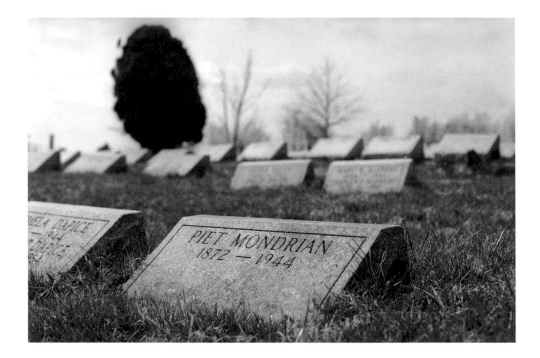

Piet Mondrian, 1872–1944, Cyprus Hill Cemetery, Brooklyn, New York, USA

Opposite: *Alfred Stieglitz, 1864–1946*, Lake George, New York, USA

Gertrude Stein, 1874–1946, Le Cimetière du Père-Lachaise, Paris, France

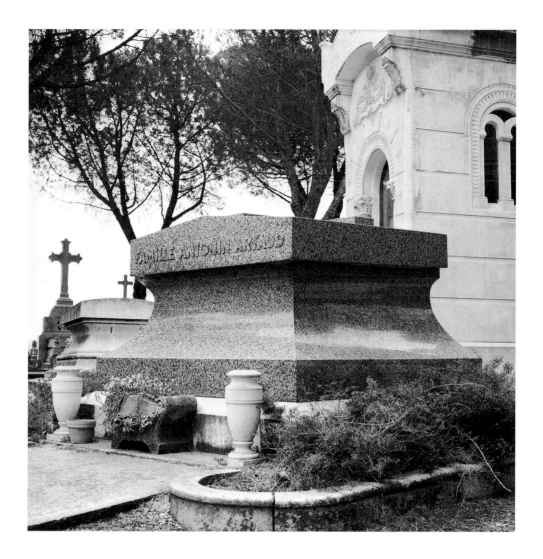

Antonin Artaud, 1896–1948, Cimetière St Pierre, Marseilles, France

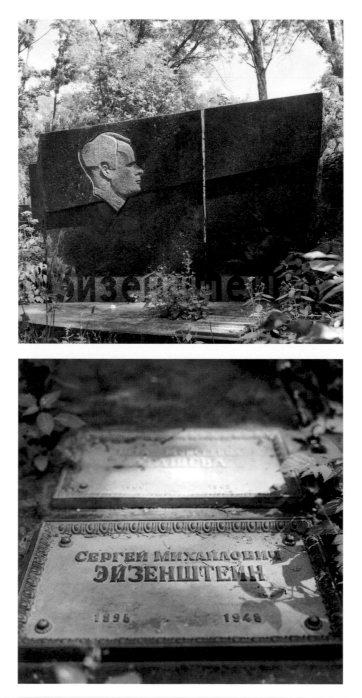

Sergei Eisenstein, 1898–1948, Novodevichy Cemetery, Moscow, Russia

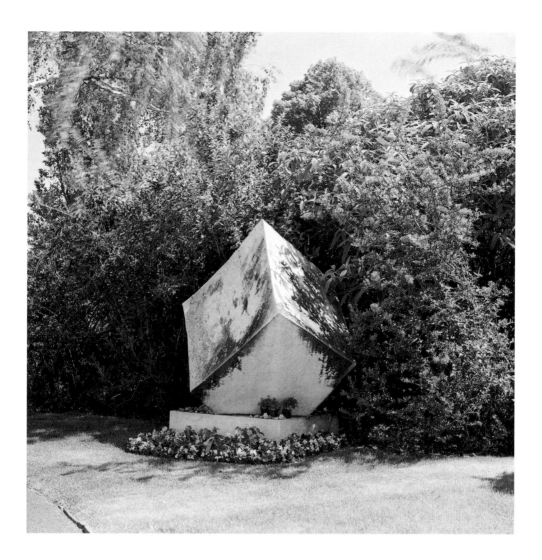

Arnold Schoenberg, 1874–1951, Zentralfriedhof, Vienna, Austria

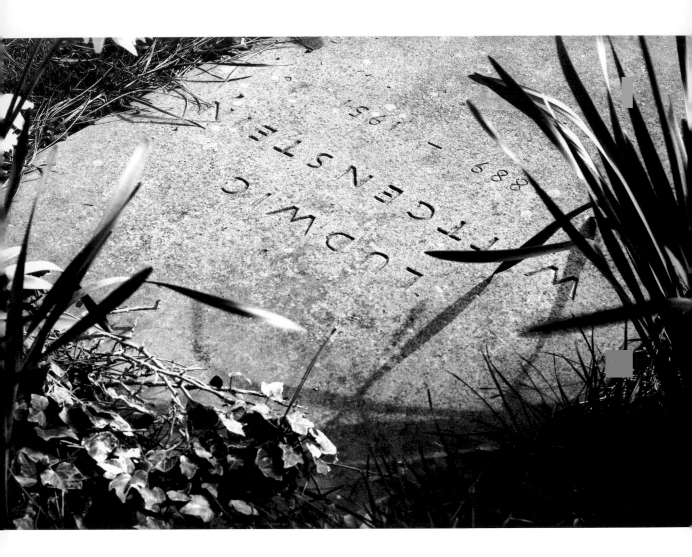

Ludwig Wittgenstein, 1889–1951, St Giles' Churchyard, Cambridge, England

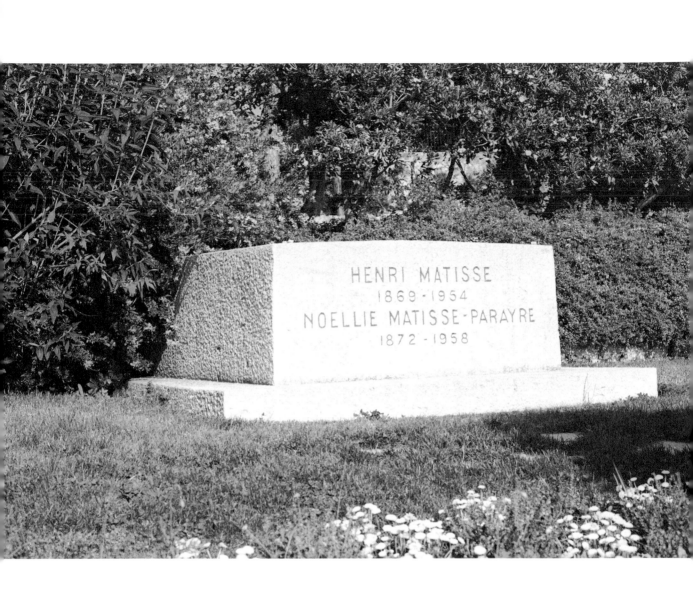

Henri Matisse, 1869–1954, Musée Franciscan–Eglise et Monastère de Cimiez, France

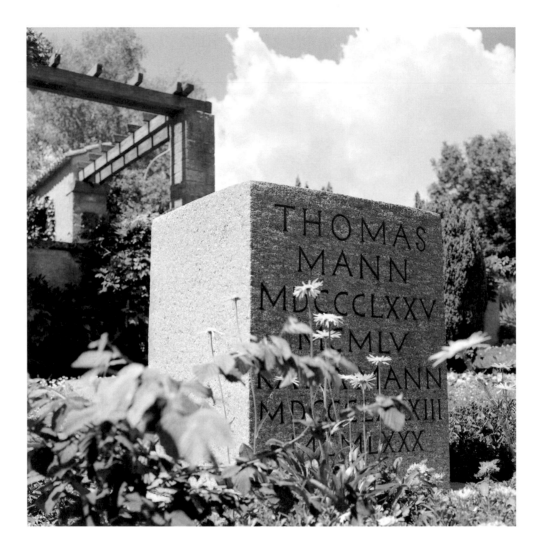

Thomas Mann, 1875–1955, Kilchberg, Switzerland

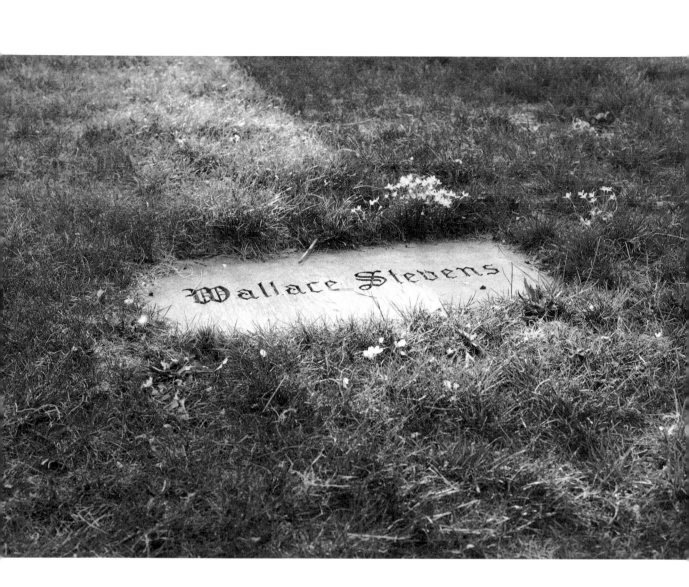

Wallace Stevens, 1879–1955, Cedar Hills Cemetery, Hartford, Connecticut, USA

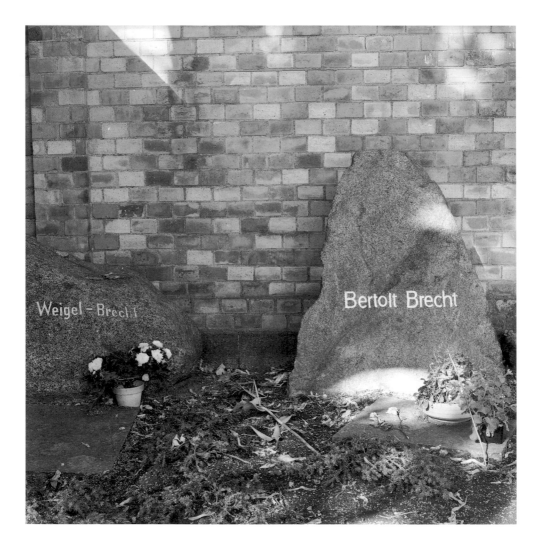

Bertolt Brecht, 1898–1956,
Dorotheenstädtische Friedhof und Friedrich-Werschen Gemeinder,
Berlin, Germany

Jackson Pollock, 1912–1956,
Green River Cemetery,
East Hampton, New York, USA

Constantin Brancusi, 1876–1957, Cimetière du Montparnasse, Paris, France

Frank Lloyd Wright, 1867–1959, Unity Chapel, Spring Green, Wisconsin, USA

Albert Camus, 1913–1959, Lourmarin Cemetery, France

Carl Jung, 1875–1961, Fluntern Cemetery, Zurich, Switzerland

Maurice Merleau-Ponty, 1908–1961, Le Cimetière du Père-Lachaise, Paris, France

Opposite: *Ernest Hemingway, 1898–1961*, Ketchum Cemetery, Idaho, USA

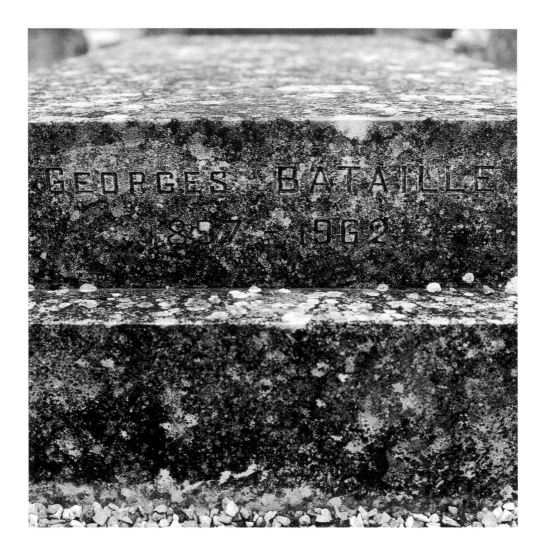

Georges Bataille, 1897–1962, Vézelay, France

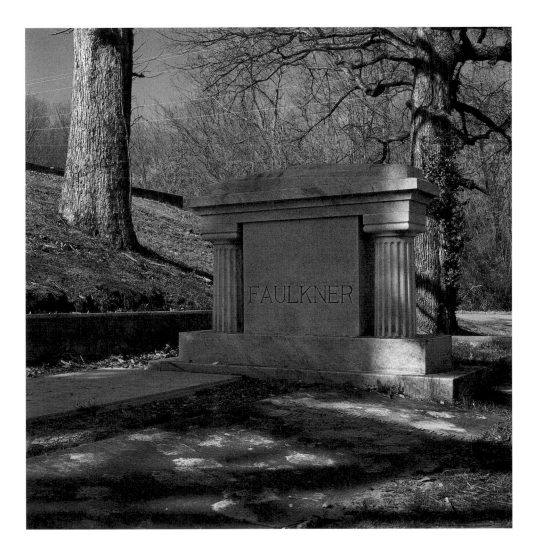

William Faulkner, 1897–1962, St Peter's Cemetery, Oxford, Mississippi, USA

Georges Braque, 1882–1963, Varengeville, France

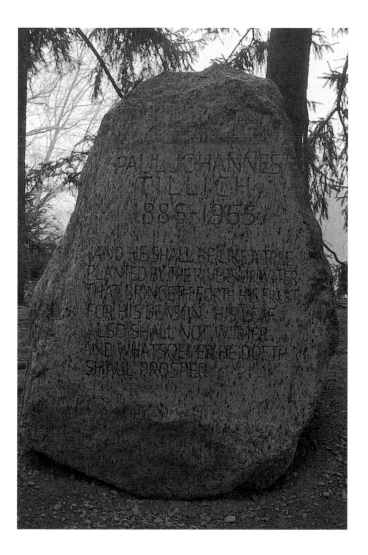

Paul Tillich, 1886–1965, New Harmony, Indiana, USA

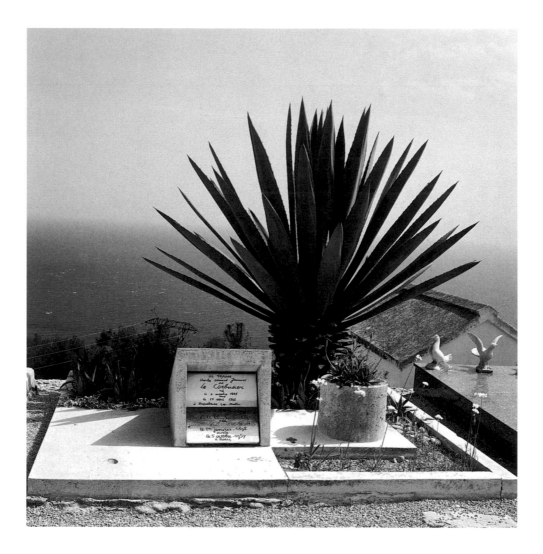

Le Corbusier (Charles-Edouard Jeanneret), 1887–1965, Roquebrune, France

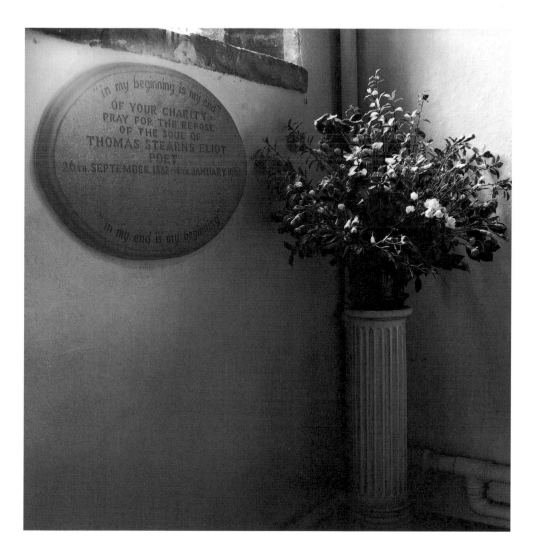

T. S. Eliot, 1888–1965, East Coker, England

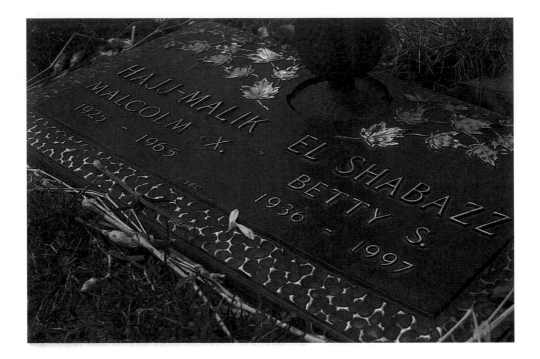

Malcolm X, 1925–1965,
Ferncliff Cemetery,
Hartsdale, New York, USA

Alberto Giacometti, 1901–1966,
Borgonovo, Switzerland

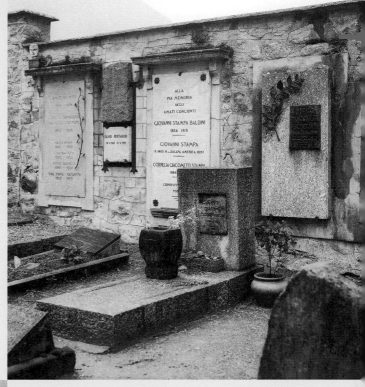

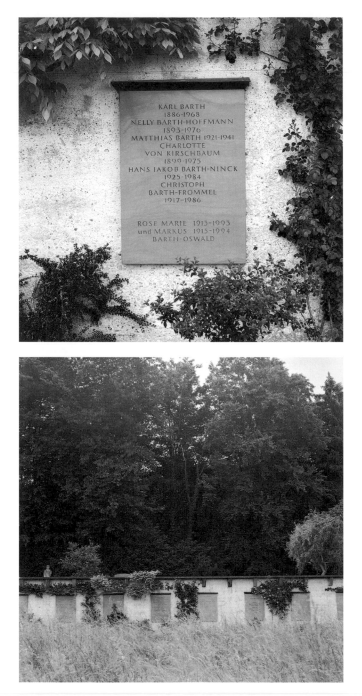

Karl Barth, 1886–1968, Hornli Cemetery, Basel, Switzerland

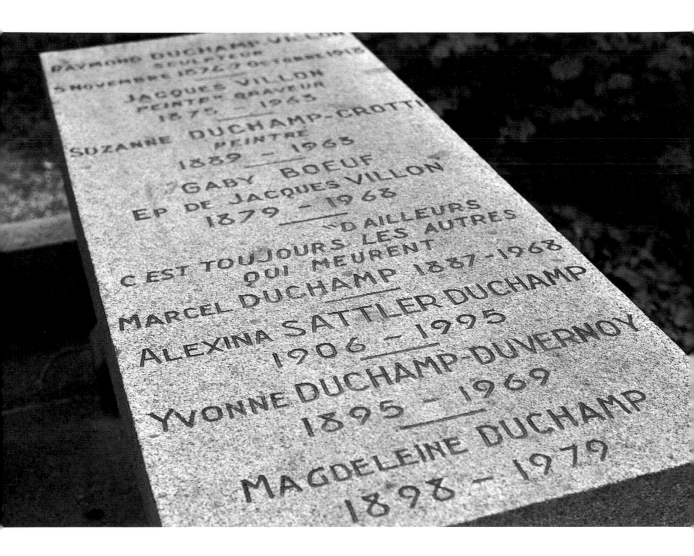

Marcel Duchamp, 1887–1968, Cimetière Monumental, Rouen, France

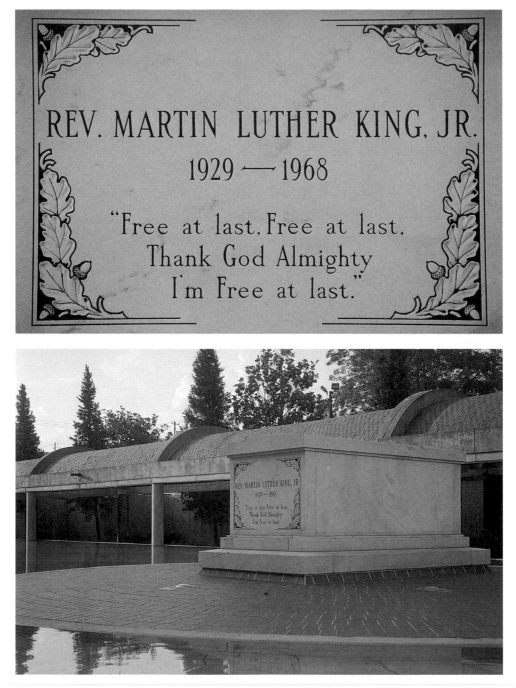

Martin Luther King, 1929–1968, Martin Luther King Center, Atlanta, Georgia, USA

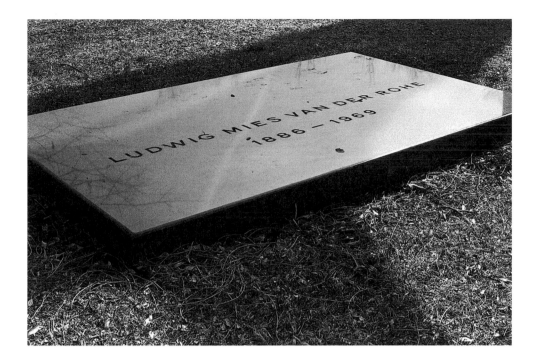

Ludwig Mies van der Rohe, 1886–1969, Graceland Cemetery, Chicago, Illinois, USA

Bertrand Russell, 1872–1970, Colwyn Bay, Clwyd, Wales

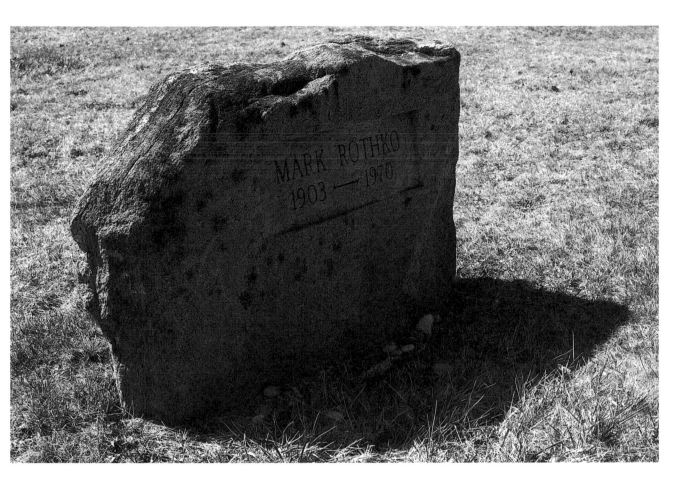

Mark Rothko, 1903–1970, East Marion Cemetery, New York, USA

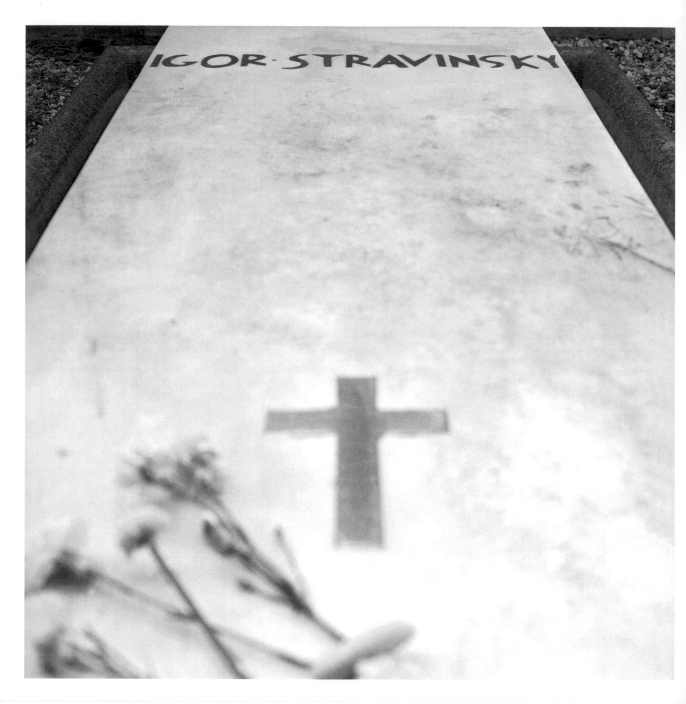

Igor Stravinksy, 1882–1971, San Michele Cemetery, Venice, Italy

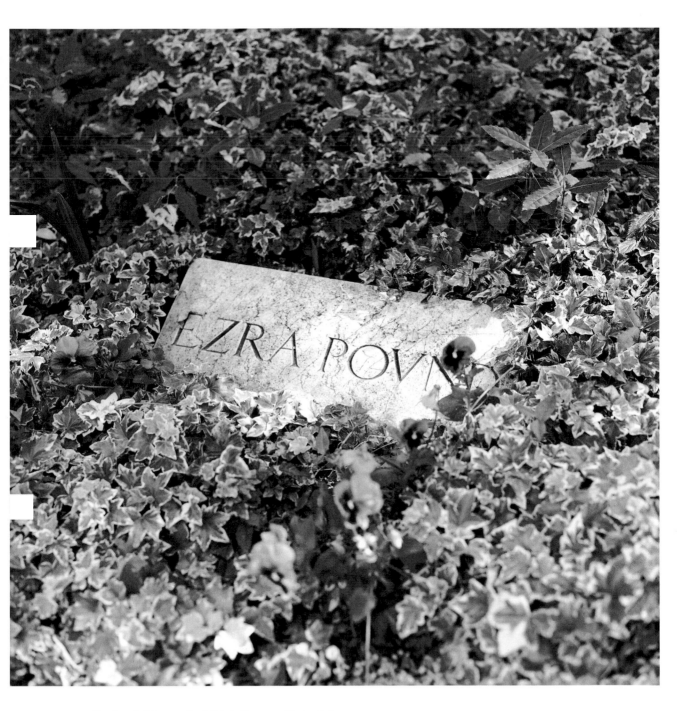

Ezra Pound, 1885–1972, San Michele Cemetery, Venice, Italy

Pablo Picasso, 1881–1973, Vauvenargues, France

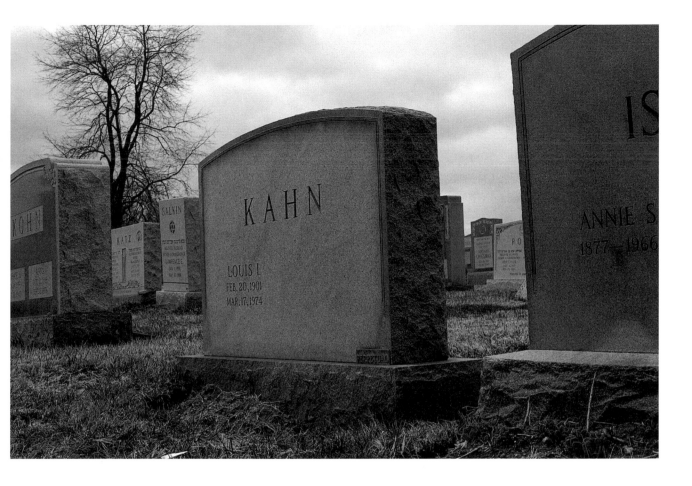

Louis Kahn, 1901–1974, Montefiore Cemetery, Philadelphia, Pennsylvania, USA

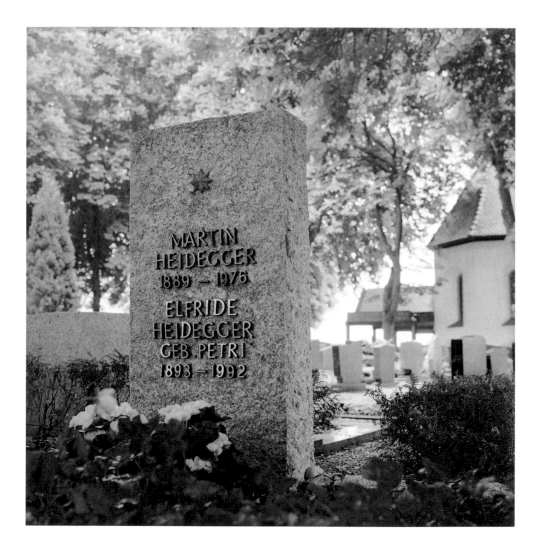

Martin Heidegger, 1889–1976, Messkirch, Germany

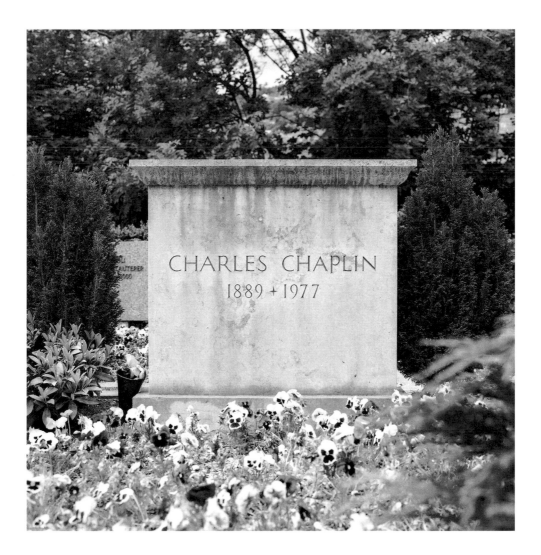

Charlie Chaplin, 1889–1977, Corsier-sur-Vevey Cemetery, Switzerland

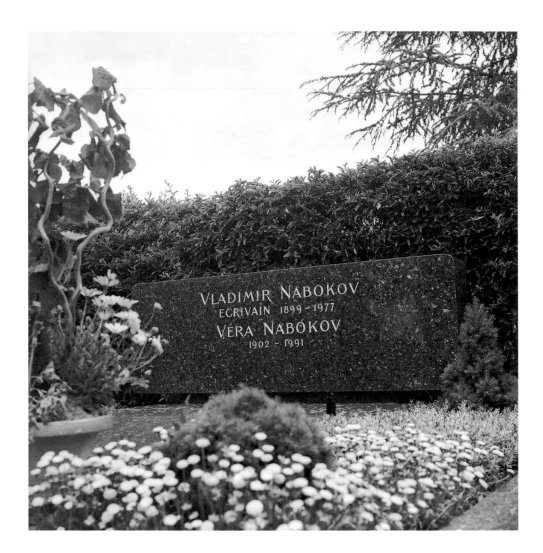

Vladimir Nabokov, 1899–1977, Clarens, Switzerland

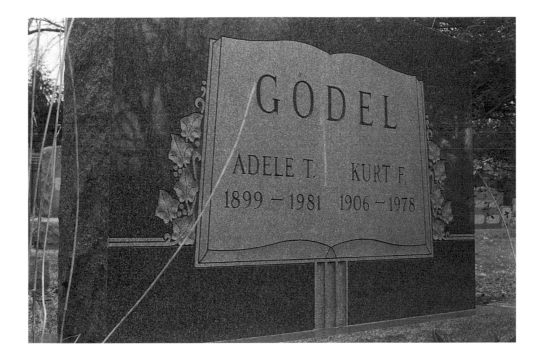

Kurt Gödel, 1906–1978, Princeton Cemetery, New Jersey, USA

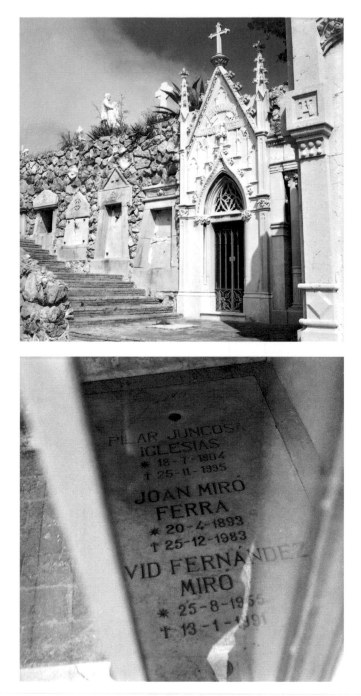

Joan Miró, 1893–1983, Montjuic Cemetery, Barcelona, Spain

Lee Krasner, 1908–1984, Green River Cemetery, East Hampton, New York, USA

Michel Foucault, 1926–1984, Vendeuvre, France

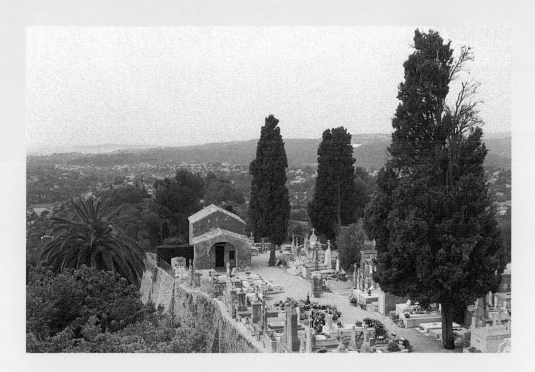

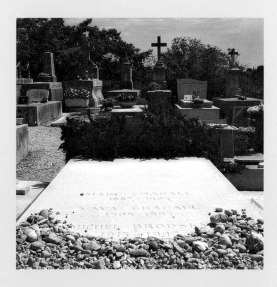

Marc Chagall, 1887–1985,
St Paul Town Cemetery,
St Paul de Vence, France

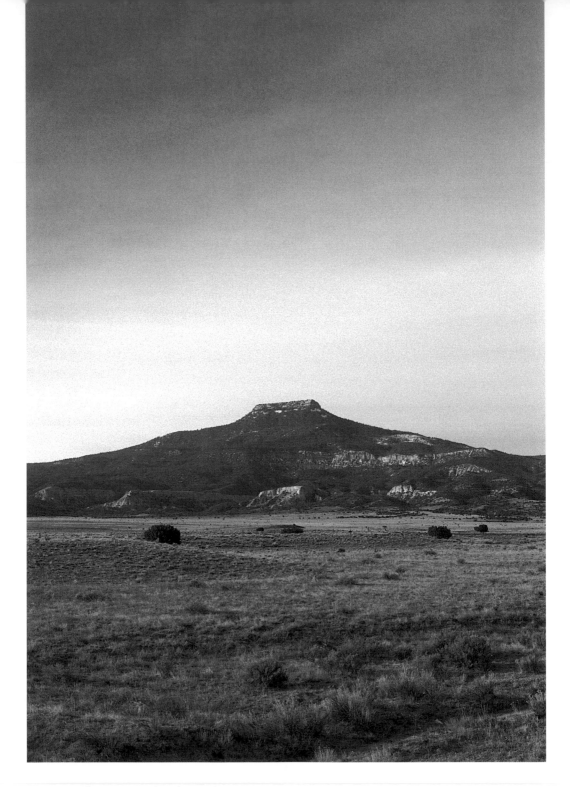

Georgia O'Keeffe, 1887–1986, Pedernal, near Abiquiu, New Mexico, USA

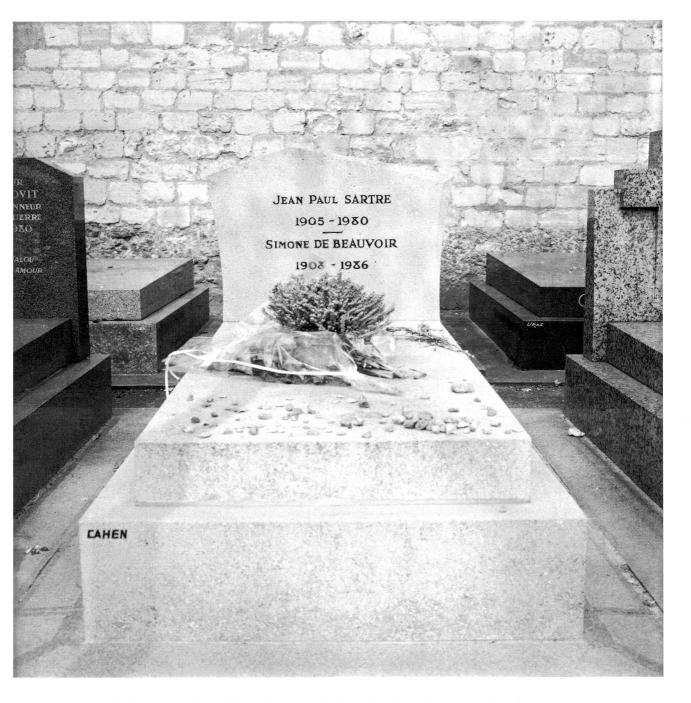

Jean-Paul Sartre, 1905–1980, and *Simone de Beauvoir, 1908–1986,* Le Cimetière du Montparnasse, Paris, France

Joseph Beuys, 1921–1986, Helgoland Bight, North Sea

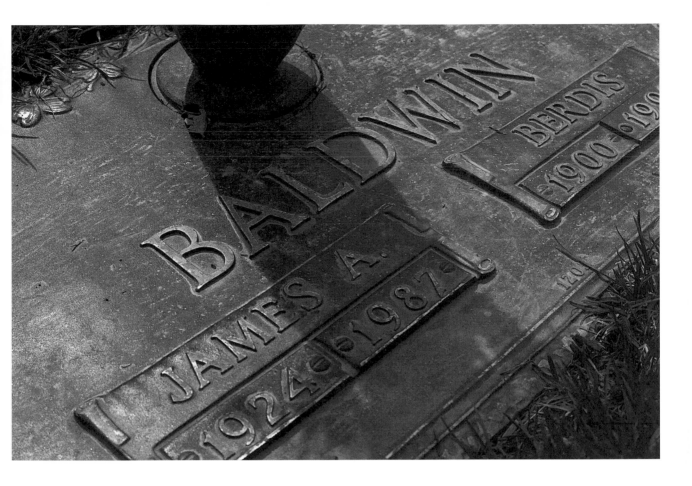

James Baldwin, 1924–1987, Ferncliff Cemetery, Hartsdale, New York, USA

Andy Warhol, 1928–1987, St John the Baptist Cemetery, Bethel Park, Pennsylvania, USA

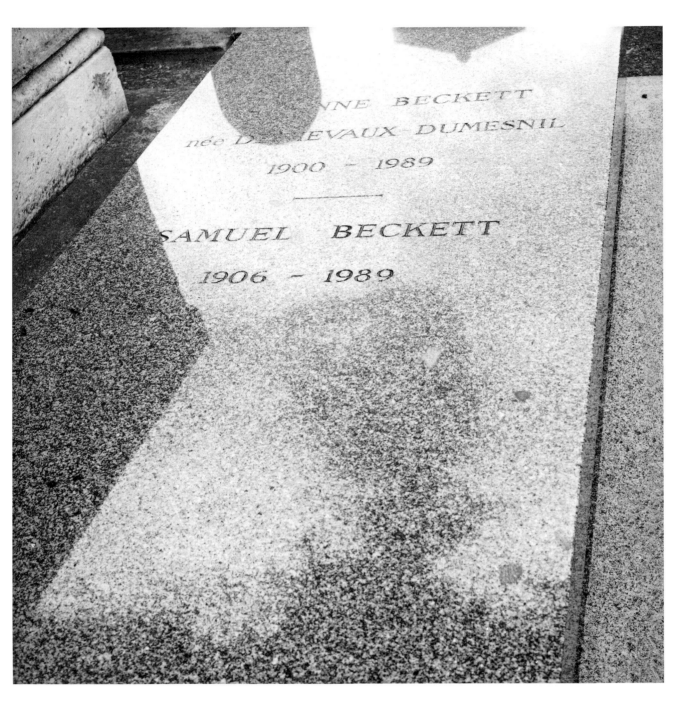

Samuel Beckett, 1906–1989, Le Cimetière du Montparnasse, Paris, France

Ralph Ellison, 1914–1994, Trinity Church Cemetery, New York, New York, USA

Mark C. Taylor, 1945–, South Lawn Cemetery, Williamstown, Massachusetts, USA

ACKNOWLEDGEMENTS

Conducting the research and gathering the materials for *Grave Matters* has required more than four years and taken us across several continents. The completion of a project of this scope would have been impossible without the interest and support of many people. We would like to express our sincere appreciation to Robert Trumbull, for finding grave sites we thought could never be found; Shawn Rosenheim, Director of the Center for Technology in the Arts and Humanities, Williams College, for providing a place to do our work; Morton O. Schapiro, President, and Thomas Kohut, Dean of the Faculty, Williams College, for generous institutional support; Michel Conforti and Michael Ann Holly, Clark Art Institute, for their invaluable encouragement and advice; Joseph Thompson, Director, Massachusetts Museum of Contemporary Art, for his aesthetic judgment and critical suggestions; Margaret Weyers, Williams College, for her patient support day in and day out; Paul Lieberman of the *Los Angeles Times*, for pushing us into places we preferred to avoid; Dale Riehl, Riehl Company, for visual insights that deepened our work; Eve Andrée Laramee, for her keen aesthetic sensibilities; John Kim, for his imagination and determination; Caroline Messmer, for uncovering stories we never suspected; Noah Peeters, for being where we could not be; John Le Claire, for help with photography; and Marq Smith, for his eager interest and steady support.

M. C. T. and D. C. L.

Along with the foregoing acknowledgements, I would feel it inappropriate not to recall the spectre of those who made it possible for me to spend more than two years on the road in innumerable countries, in often derelict villages and forgotten cemeteries, shooting the images in *Grave Matters*. Many of these people, as is often the case, remain peripheral, which is not to say unimportant. As it says on the memorial to Benjamin in Port-Bou, 'Schwerer ist es, das Gedächtnis der Namenlosen zu ehren als das der Berühmten.' These images are dedicated to the nameless. For support without which my work on the road would have been impossible, I would like to thank Bruno Caillet, Lindsay Benedict, Stéphanie Bourdin and C. Matthew Chen in Paris; Karolina Hübner and Roland Meeks in Edinburgh and London; and Ulrike Hanke and especially John Kleberg in Berlin; my mother, Suzanne L. Lyon, John Kim, Gregory Whitmore of the Center for Technology in the Arts and Humanities, Williams College, and Jason Gladstone in America. And, finally, Mishima Roko in Tokyo.

D. C. L.